DISTURBING ART LESSONS

A Memoir
of Questionable Ideas
and Equivocal Experiences

DISTURBING ART LESSONS

A Memoir
of Questionable Ideas
and Equivocal Experiences

Eli Levin

SANTA FE

© 2012 by Eli Levin
All Rights Reserved.

No part of this book may be reproduced in any form or by any electronic or mechanical means including information storage and retrieval systems without permission in writing from the publisher, except by a reviewer who may quote brief passages in a review.

Sunstone books may be purchased for educational, business, or sales promotional use. For information please write: Special Markets Department, Sunstone Press, P.O. Box 2321, Santa Fe, New Mexico 87504-2321.

Book and Cover design › Vicki Ahl
Body typeface › Bell MT
Printed on acid-free paper

Library of Congress Cataloging-in-Publication Data
Levin, Eli, 1938-
Disturbing art lessons : a memoir of questionable ideas and equivocal experiences / by Eli Levin.
 pages cm
 ISBN 978-0-86534-859-2 (softcover : alk. paper)
 1. Levin, Eli, 1938- 2. Artists--United States--Biography. I. Title.
 N6537.L444A2 2012
 709.2--dc23
 [B]
 2011051281

WWW.SUNSTONEPRESS.COM
SUNSTONE PRESS / POST OFFICE BOX 2321 / SANTA FE, NM 87504-2321 /USA
(505) 988-4418 / ORDERS ONLY (800) 243-5644 / FAX (505) 988-1025

Dedicated to all those artists who got off on the wrong foot.

CONTENTS

Childhood Art / 9
Music And Art High School, 1952-1956 / 11
The Art Students League, 1954-1955 / 14
Enter Robert Smithson / 17
Art Students League Revisited / 20
Other Early Drawing Experiences / 22
Philip Reisman / 23
Reisman Revisited / 25
Yet Another Drawing Group / 26
Charles Haseloff / 27
Admired Artists / 29
Museums Then / 31
 The Whitney / 31
 The Guggenheim / 32
 The MOMA / 32
The Art Galleries / 34
Art For The Public / 35
Teen Bohemia / 36
Robert Smithson Again / 38
Skowhegan School Of Art / 41
Cummington School Of The Arts / 44
Brandeis University / 46
 Arnold Hauser / 47
 Leo Bronstein / 47
 Bronstein Again / 48
 In the Back Streets of Cambridge / 49
 A Traumatic Incident / 49
Raphael Soyer / 51
The Realist Protest / 54
John Koch / 56
My Attempts To Exhibit / 59
My Career As An Art Critic / 61
Advice From The Master / 63
The New School For Social Research / 65
The Boston Museum School / 67

Boston Friends / 70
I Have A Dream / 71
Henry Geldzahler / 72
Dick Stroud / 73
Museums In Boston / 77
Starting My Art Career / 79
Breakdown / 81
A New Start / 82
Wandering / 84
 Taos / 84
 Santa Fe / 87
 New York Again / 88
Back To Academia, 1965-1966 / 90
 Etching / 92
 Robert Beverly Hale / 94
 Gary Faigin / 97
 Goodbye to the Academy of Realist Art / 98
 From Student to Teacher / 99
 More Attempts at Teaching / 100
 Teaching Again / 101
 Last Attempt to Teach Drawing / 102
Drawing / 104
Book Learning / 107
 How To / 108
 Aesthetic Brainwashing and Censorship by Omission / 109
 Mean Artists and Nice Artists / 111
 Books About Aesthetics / 112
The Secret Of Art / 113
 Art for the People / 113
 Jealousy and Art / 114
 A Technical Digression / 115
Art Peeves / 118
 Lies About Art / 118
 Thoughts About Academic Art / 119
Gallery Business / 121
Lives Of The Paintings / 123
Ars Longa, Vita Brevis / 124
Negativity / 125
Inspiration / 126
Disturbing Art Lessons / 128

Childhood Art

My parents, who were divorced as far back as I can remember, both encouraged me to draw and paint.

I often spent time with my mother's best friend, Maxine Picard, a sculptress. Maxine's studio was in the attic of an imposing old building on 14th Street in New York. I respected and loved Maxine and wanted to be an artist like her. Maxine showed me how to build an armature and model the figure of a football player in clay.

In the studio next to Maxine's was Armin Landeck, a well-known engraver. I have one of his engravings, framed, hanging over my desk today. The engraving depicts the stairwell and hallway that led to his and Maxine's studios. Under the image Landeck wrote in pencil "For Mable, Merry X-mas." Mable was my mother.

Armin Landeck showed me how to hold the *burin*, used to engrave copper, a technique that has not changed since the Renaissance. This I still do.

My father, Meyer Levin, was a writer and knew many artists. His second wife was the daughter of Marek Sczwartz, a Polish sculptor who lived in Paris. On my summer visits, from age nine to twelve, I visited Marek's studio. It was in a complex of studios built around a garden. This studio had a huge slanting north window and a little balcony that overlooked the workspace. Later in my life I built my own studio imitating that design.

In 1948, having flown from New York to Paris in a propeller plane, I was dazedly walking down a boulevard with my father. We met a writer whom Meyer knew, Arthur Zaidenberg. Zaidenberg told us he was writing a book on children's art. My father mentioned that I was an aspiring artist. I had some watercolors in my suitcase, three of which

Zaidenberg took and used in his book *Your Child is an Artist*, published in 1949.

Andy Warhol said that everyone would be world-famous for fifteen minutes. I was granted my fifteen minutes at age eleven.

Music And Art High School, 1952-1956

In my teenage years, I was intensely involved with art. I felt that I was an artist and that it was intoxicating and exalting. That was fifty years ago. Subsequently, my life as an artist, while intriguing, has been accompanied by endless doubts.

My first oil painting class was taught by the much-idolized Mr. Bloomstein. Right away, he showed us how to stretch canvases, how to prime them with rabbit-skin glue warmed in a double boiler, and how to lay out little dabs of color on our wooden palettes.

I felt initiated into the sacred rituals of the artist's studio. Most teachers and artists whom I have encountered since then do not concern themselves with these rudimentary skills. They buy pre-stretched canvas, prepare various surfaces with acrylic gesso instead of hide glue, and squeeze tubes of paint onto their palettes in a chaotic manner.

Our first assignment was to paint still lifes. Bloomstein had brought to class a big basket of apples. Taking seven, I set about arranging them on my section of the long classroom table.

Bloomstein approached, raising his voice for all to hear. "No. Using so many apples is redundant. One will make a stronger statement."

To this day I struggle with the choice between repetition and reduction. Classicist theory advocates reducing the elements in a work of art to their simplest and most pure form. A Baroque, Romantic, or Expressionist approach emphasizes the exceptional and excessive.

"How do we paint the apple?" several students queried.

"Any way you want to, but . . . make it look good enough to eat."

Bloomstein's seemingly offhand comment was quite a challenge. It brought up the questions of the artist's feelings and motivations as well as the necessity to communicate. These issues bring to mind a perennial

controversy that was current at the time: *Form versus Content*. This was the title of an art book by Sheldon Rodman that had just been published. Also implicit in Bloomstein's comment was the concept of synesthesia, of one sense eliciting another, in this instance sight and taste.

I proceeded to paint the apple, table top and window, all outlined in heavy blue, like a Rouault or a stained glass window. My classmates loved it. I did this because I couldn't control the pigment, couldn't realize the subtle values that I saw. I had used a stylistic trick to avoid subtleties that I couldn't handle.

The same week, our watercolor teacher, old Mrs. Ridgeway, gave us her demonstration of how to paint an apple. She dipped a large pointed brush into a glass of water, then rubbed one side on the green tab of paint and the other side on the red tab. Then she lowered the brush sideways onto the paper and slowly twirled it. One stroke and a luscious apple appeared.

This was the first clever technique I was taught. Watercolor teachers have many, many more.

"The greatest watercolor artist of our century was John Marin," said Mrs. Ridgeway as she held up some reproductions of his helter-skelter landscapes and seascapes. I was baffled. Marin's sloppy dabs and dashes seemed childish, his simplified cubist shapes mere ciphers. Since then I have learned of the critical importance given to the early American Moderns. I still don't like their work.

Ridgeway also taught two-dimensional design, which ironically deals with creating the illusion of a third dimension. She gave us pieces of paper in many colors and asked us to cut out little triangles, rectangles, and circles. We placed these on whole colored sheets and moved them around, creating "visual tension." This was exciting. I placed a little yellow triangle and a larger red square on a dark blue sheet of paper. Which one appeared to be coming forward, which receding?

Mrs. Ridgeway told us about the Bauhaus. She knew a good deal, as she had studied in Chicago with some of the well-known refugees from Germany.

This exercise was *form* at its most fundamental and pure, totally

divorced from *content*. I was amazed that there were schools of artists devoted to these floating forms—pioneer Modernists that our high school teacher had known personally.

Another day, Ridgeway gave each of us a reproduction of a famous painting and a piece of tracing paper, asking us to trace the main lines of the compositions. At first, every line seemed important to me. She had given me a Cezanne painting of bathers, the one with big trees slanting awkwardly inward on both sides. Once I got her concept it was a bit disappointing: just a giant triangle. It transpired that there were triangular compositions in almost all the reproductions.

Reducing a crowd of nudes in a landscape to the formalist concept of a triangle would seem to be eliminating a great deal of what is essential. Yet compositions do need underlying structures to give them strength, and the foundation of many a design is in the relationship between an interior triangle and the exterior rectangle.

After a number of these design classes, I hesitantly raised my hand.

"Mrs. Ridgeway, can a face be abstracted?"

"Why, yes. Anything can be abstracted. All great paintings have an abstract structure."

"But . . . a face? In a portrait don't the eyes, nose, and mouth have to be in the right place?"

"No. But even if they are, the structure is still based on abstract principles."

I didn't believe her. Picasso, okay. But what about Rembrandt, Van Eyck? Now I see that the problem was in having thought two-dimensionally. There is a three-dimensional geometry inherent in all structures that could perhaps be termed Abstract. Strong art is developed from the most basic forms toward elaboration.

The Art Students League, 1954-1955

While I was in high school I went every Tuesday evening to the Art Students League on West 57th Street to study drawing with the illustrator John Groth. I was his youngest student. The first week, a paunchy old guy who was drawing next to me said, "I see you're not afraid to put in the nipples." I looked over at his drawing. He had left them out.

The breast is basically a sphere and, aesthetically speaking, nipples are little more than local color. It is easy to overemphasize them when working in black and white. Forget form. Content-wise, they have their place.

Groth taught the Nicolaides Method. We all bought Nicolaides' book *The Natural Way to Draw*, which was popular at the time. It's a great title, but there's nothing natural about the Nicolaides method, which is based on an obsession with gestures and contours. At first I was intrigued by trying to scribble an action pose in one minute or less. More frustrating were the painstaking meandering outlines that we tried to inscribe without looking down at our pads.

Since then I've seen hundreds of students and even mature artists repeating these useless mannerisms. With gesture and contour one never learns structure, shading, anatomy or composition.

Nicolaides had the poetic idea of drawing trees from the trunk up, "naturally, as the tree grows." I tried and tried, but the branches always ran off the top and sides of the page. Finally I realized that if I started with the crown of the tree and went down, I could get it all in.

John Groth was a true master of the gesture drawing. He insisted that we carry sketchbooks with us at all times and do at least five gesture drawings a day. He checked our sketches. I filled 20 sketchbooks,

100 pages each. My drawings were almost indistinguishable, scribbly depictions of people in subways and coffee houses.

Better if I had made studies of specific things: types of clothing, architectural elements, vehicles, things that I could use to give veracity to future paintings.

John Groth loved Daumier. Daumier is practically the only artist who did pure gesture drawings. Other Groth favorites were Heinrich Kley, Thomas Rowlandson, Tintoretto, and Hokusai. These artists have a restless use of line that suggests movement.

Exemplars of the other Nicolaides obsession, pure contour, were also rare. Ingres was the master, impossible to emulate. Others were the German Nazarenes, early Degas, Picasso in his Classical phase, and a few Calder drawings that look like bent wires.

While gesture is Romantic and Expressionistic, contour is a more Classical approach that distinguishes figure from ground and establishes proportions.

Groth's strong suit as a teacher was that he taught us to compose. This was not Bauhaus, but rather its antithesis, illustration. Groth gave a homework assignment each week. For instance: "Draw a composition including someone working," or "Draw several people in the street."

After we had been drawing the model for a couple of hours we would line up our homework on a long ledge. For the third hour of class we listened to Groth's criticisms and voiced our own thoughts.

Critiques can be painful but are essential feedback. No matter how self-involved artists may be, they should at least be aware of how others react to their work.

My first composition, "Someone Working," inspired by Eugene O'Neill's play *The Hairy Ape*, depicted a man shoveling coal into a furnace. I was pleased with my picture until Groth pointed out that it was "too static. You've spaced out the components evenly across the page: coal, stoker, oven."

Halfheartedly, I ventured that "I was trying to express the social immobility of the worker." This was the kind of leftist sentiment that my folk-singing friends and I shared.

Of course for John Groth if it was static, it couldn't be interesting. Action was his gospel: diagonals plunging into depth; figures overlapping and swirling, clusters opposing voids; gestures culminating in an apotheosis of movement.

From Groth on, I've heard endless references to movement in works of art. What is it? Are various elements in the picture supposed to be in movement or about to move? Or is the viewer's eye supposed to move around the picture, the artist somehow having directed its path? It is possible that a viewer will look at a picture sequentially. Most artists wouldn't want some insignificant detail to be the first thing to catch the viewer's eye. But there are so many kinds of pictures, and so many ways to read them. In many paintings it is the general impression that is paramount.

John Groth introduced us to a peculiar book, *Cezanne's Compositions*, written by a man named Lorenz. In it, dotted lines and arrows are superimposed over Cezanne reproductions. The accompanying text then explains Cezanne's seemingly illogical distortions as devices intended to move the viewer's eye around. I studied the book assiduously, but Cezanne's compositions continued to appear static to me, and awkwardly drawn. Even if I thought that my eye could be made to follow some predetermined course, I would prefer the flow of Rubens to the faltering broken pattern of Cezanne.

Enter Robert Smithson

Robert Smithson, who later became famous as the *enfant terrible* and martyr of Earthworks, was also in Groth's class. He and I were the teacher's pets.

Groth recommended that Bob and I visit the little library in the League basement. There we discovered books on Daumier, Heinrich Kley, Goya, and others. Drawings, especially nudes; how exciting this was. The Kleys were sexy and perverse. We gaped at Degas' monotypes of squat whores and were disturbed by George Grosz' bestial Berliners. This was strong stuff for young teenagers in the 1950s.

On a more aesthetic level, Bob and I were awed by Da Vinci's anatomical studies, especially those of an emaciated old man, and we were overwhelmed by the idealistic figure studies of Raphael and Michelangelo.

John Groth was as handsome as a Hemingway adventurer, always wearing a safari vest. He had been a war artist and was rumored to have married an heiress. Groth's two books, *Studio Europe* and *Studio Asia*, transcribed his war experiences and were crammed with on-the-spot gesture drawings. Of course I bought copies of both. In the first book, I remember a sketch of a dead cow that a bomb had blown into a tree. Also there was an on-the-spot portrait of Picasso. The second book featured a couple of sketches of Chiang Kai-shek. It seemed that being adept at gesture drawing was the royal road to adventure.

While criticizing our drawings, Groth used to point out that the more we concentrated on one particular part, the bigger it got. "When I drew Picasso's head, it grew and grew until it filled the whole page."

It takes tremendous awareness and control to keep the parts

in proper relation to the whole. I believe that this is one of the crucial concepts of art.

While Smithson and I were studying with Groth, we made fun of the academic teachers: Reilly, Brackman, Mason, and Phillips. To us they were commercial artists, the lowest of the low. Their prize students went on to paint the lurid covers of paperback novels.

When one of Reilly's students earnestly showed us how they started a nude study with a diagrammatic stick figure, we protested that this was a mechanical gimmick that would inhibit feeling. The student responded, "You have to learn how to crawl before you can walk." We thought that was hilarious—so pathetic. Bob and I would often repeat the phrase, giggling, while we flogged away at our gestures and contours.

We believed in inspiration, creativity, self-expression. By disdaining everything philistine, we would achieve greatness. This was blind Romanticism, and very exhilarating.

John Groth's students were mostly women. I particularly remember one named Eve: lovely, shy, sweet-tempered, naturally elegant. She had some connection to the composer Giancarlo Menotti. Groth jestingly referred to her as his adopted daughter and seemed to be in love with her.

Smithson and I were invited by Groth to visit his studio. It was a couple of blocks from the League in a big office building. His space was disappointing, just two office cubicles connected by a doorway. On his desk and an adjacent table were illustrations of circus scenes that he was working on. There were also some cartoons he was doing for *Playboy* magazine: big-breasted women and silly men. On the wall was a large painting of a tenement building featuring goings-on in every window. The concept derived from George Grosz, but John Groth's approach was lighter and more cartoony. Where were the Romantic artist's quarters, the incisive scorn of a modern-day Daumier?

In a sudden shift of mood, Groth pulled out a desk drawer and revealed stacks of photographs taken in concentration camps. Some of these harrowing images I was familiar with. My father had his own Holocaust library and I'd been reading more of those books than was

good for me. Groth's photos were more disturbing for being raw material and shocking in the possession of such a genial outdoorsy type.

"What are you doing with these?" I asked.

"I don't know. I'm not sure. Thinking about them."

Like John Groth, an untold number of artists, probably even most artists, struggle with unrealized visions.

At the League, Groth was teaching us in a large studio on the very top floor, five flights up. There was an elegant staircase that was later torn out to make room for an elevator. Groth's classroom, removed from outside reality, was always welcoming and warm, the classes like an enjoyable party.

Nothing in an artist's life is quite as exciting as his happy student days, so full of idealistic expectation. My happy times in Groth's class lasted two years. Then one of the students informed the administration that Groth was letting me come to his classes for free. Why free? I don't know. Perhaps because he was doing my father a favor or because I was so young.

While we were drawing, Stuart Klonis, director of the Art Students League, burst into the studio. He was red-faced and puffing from climbing all those stairs. He asked to see our class tickets. Not having one, I had to leave. The fee was reasonable, but my father never offered to pay.

Art Students League Revisited

Thirty years later, I returned to the League to study anatomy with Robert Beverly Hale. On a whim, I looked up John Groth in the school catalog. He was still teaching. I bought a ticket to attend his class. It was in a different studio, a windowless, boxlike, stuffy space on the ground floor. When I entered, the students were already seated in a circle around the model stand, doing one-minute gesture drawings. I found an empty chair and opened my sketchpad, which was notably smaller than their newsprint pads. I felt very nervous, and found it almost impossible to do those fast, scribbly drawings, but I tried.

The claustrophobic studio was analogous to my loss of faith in Groth's teachings. I couldn't even do this simple exercise that I had performed thousands of times before.

John Groth appeared. But wait . . . he hadn't aged. He even looked younger than I remembered him. This man was wearing the safari jacket and sporting the droopy moustache, but he couldn't be John Groth. He was a clone.

This surrogate Groth walked around behind me, peered over my shoulder, then said, "Your drawings are too tight, too finicky, too literal. You're not feeling the swing of the movement, the gesture."

"Oh," I muttered. Then I managed to add, "Is John Groth going to be here tonight?"

"He'll join us later for the critique."

I continued to draw, but without improvement, dreading another critique. After a couple of hours, Groth showed up. Here was another even more disturbing variation of the original Groth. This man was seedy, as fragile as a shell, dim-eyed.

I introduced myself to him, described the old days, mentioned

Bob Smithson. At first he drew a blank, but slowly something seemed to come back to him. "Ah yes. You were very young and talented. I knew you had something. And you became well known. Earth Art, the Spiral Jetty." He thought I was Smithson.

"Do you remember a young lady who was in my class named Eve?" Groth continued after a moment.

"Yes," I said. "I remember her well."

John Groth then became lost in thought and drifted away, glancing at other students' work. I drew for a while; Groth approached again. He motioned toward another student, a teenage girl, young, pretty, and innocent-looking, a few seats away from me.

"That's Eve's daughter," Groth said dreamily. "I adopted her when her mother died."

Then Groth went over to her and said, "This fellow, Bob, was in my class at the same time that your mother was."

I couldn't help pondering: Since there was in effect another Groth and another Eve, and I was another Bob, perhaps among these earnest students who were trying to master the one-minute gesture there was yet another Smithson or another me. Surely, like us, some of them dreamt of becoming great artists. Maybe Groth, Smithson, and one or two of these new students were the ones who had the true art spirit, while it was I who had atrophied?

I continued at the League five days a week for two months, but I never went back to visit with Groth.

Other Early Drawing Experiences

On weekends, Smithson and I would get together with some of my friends from Music and Art High School, and we would draw each other (clothed). Among our group was Avron Soyer, the son of Isaac, who was the youngest of the Soyer brothers. We used Isaac's studio. I was intrigued by a number of paintings by Isaac that depicted women with telephones. Were they meant to be a commercial project or just unusual subject matter? Isaac was not as famous as the twin brothers, Raphael and Moses Soyer. Except for a couple of Depression-era paintings done early in his career that are sometimes reproduced, he seems to have been totally overlooked.

At about this time, 1955, I started going to the Brooklyn Museum Art School on Saturday mornings to study drawing with Moses Soyer.

Philip Reisman

Thursday evenings I went with my high school buddy, Charles Haseloff, to draw the models at Reisman's studio on East 17th Street. He let us in for half price. The other students were mostly older ladies who could afford the fee (but, we felt sure, could never be serious artists).

After the model finished, Reisman showed Charlie and me some of his own student drawings. He kept them in big flat files. They were very anatomical, Reisman having been a student of Bridgeman at the League.

Bridgeman, like the other academic teachers I've mentioned at the League, had a rigid teaching system that he popularized in many books with titles like *The Human Machine*. Surely Reisman wanted us to learn anatomy, but we were seeing the models through an adolescent romantic haze.

The models posed on a stand in front of Reisman's crammed painting racks. More paintings covered the walls, all in elaborate knobby frames that Reisman made himself. Even paintings that were barely started were already in frames. Reisman liked to work them up this way. One, titled *The Black Freighter*, was inspired by a song from the *Threepenny Opera* that we were all singing at the time. Another painting, a bar scene, depicted a waiter carrying a tray above his head. Reisman had modeled this figure in colored plasticine. The plasticine model stood on a shelf below the unfinished painting.

Working up the paintings in frames seemed too premeditated for us, but now, looking back, I admire Reisman's holistic approach, and often do the same thing. We were impressed that he worked from his own modeled figures, though this too was an elaboration we could not imagine practicing. It was a practice used by Baroque artists such as Tintoretto

and, more recently, by Thomas Hart Benton. I see the advantage in studying how the light falls on the figures, but I haven't tried it.

Workers and the dispossessed were Reisman's subjects. He exhibited at the A.C.A. Gallery (American Contemporary Art), along with other Communist and left-wing artists such as the Soyers, Philip Evergood, Charles White, Charles Gwathmey, and Joseph Hirsch. Despite Reisman's subjects, I didn't think his paintings fit with the others'. His style was old-fashioned, derived from Delacroix and Daumier.

"What is the best way to become an artist?" I asked Phil Reisman.

"You should rent a room on Coney Island for a couple of years and draw and paint everything around you."

I felt the power of this concept. It was the best advice I'd ever received, but I didn't have the courage to pursue it. I still think it was great advice.

Charlie and I had been going to Reisman's drawing sessions for about a year. While Reisman was out of the room, I overheard two of his students whispering. Reisman's 19-year-old son had been killed in an auto accident. Reisman never mentioned this tragedy. He was a shy, stiff, serious man. The knowledge of his misfortune was disturbing, and I stopped going.

Reisman Revisited

More than 30 years later I traveled from Santa Fe to New York to take a couple of months of anatomy classes at the Art Students League. I stayed with Charlie Haseloff in his Soho loft. We got to talking about Phil Reisman. Charlie looked him up in the phone book and there he was, still in the same studio on 16th Street. I called him and made an appointment for us to visit him.

Reisman looked remarkably the same. He was wearing a white shirt with the sleeves rolled up and a blue denim apron that might as well have been the one we'd last seen him in.

His recent paintings were still of the New York underclass. The style, reminiscent of Daumier, had taken on a manic vitality. His subject was street life: derelict neighborhoods, abandoned buildings and cars, punked-out gangs. An overwhelming clutch of teeming city life seemed to be careening every which way. Now an old man, Reisman still had the courage to paint life at its rawest.

Many, many paintings were carefully stacked in rack after rack. The studio space had become claustrophobic. After a moment, I realized that Reisman's loft had been divided in half, the front having been rented to another artist.

How did Reisman survive? How did he support himself, what kept him painting without any evident recognition? He was such a dignified man, one couldn't ask these questions.

While he was showing us his paintings, Phil elucidated his system for cataloging his work. He had made a slide of every painting and a corresponding index card; everything was in its place. It seemed unlikely that many paintings ever left the studio. He made a very strong impression on me. This was an artist who had kept the faith.

Yet Another Drawing Group

There was a sketch group in a basement studio in the Village. There was no teacher, but it was generally understood that members would draw freely with charcoal on large pads. I thought that my drawings were very expressive and showed them to Maxine Picard, the sculptress I'd looked up to as a child. After some hesitation she said, "I thought that you could draw better than that."

I was hurt, but Maxine was right. My "expression" was all superficial mannerism; I didn't understand anything about body structure. Since then I have been drawing models steadily for fifty years and it's still a struggle to get the proportions right, let alone a telling likeness. Now I understand Hokusai's musing:

> From the age of 5 I have had a mania for sketching the forms of things. From about the age of 50 I produced a number of designs, yet of all I drew prior to the age of 70 there is truly nothing of any great note. At the age of 73 I finally apprehended something of the true quality of birds, animals, insects, fishes, and of the vital nature of grasses and trees. Therefore, at 80 I shall have made some progress, at 90 I shall have penetrated further the deeper meaning of things, at 100 I shall have become truly marvelous, and at 110 each dot, each line shall surely possess a life of its own.

Charles Haseloff

Charlie and I liked to take long walks together, for instance from our high school on 135th Street to my parents' apartment on 99th Street, or in the evening from 99th Street to Greenwich Village. As we walked, we philosophized. Was there a God, free will, good and evil, beauty? We would end up at one of several coffee houses, such as Rienzi's, where we would imagine that we were in the center of the art world.

In 1952, Haseloff had come to Music and Art High School right out of Germany. If that wasn't culture shock enough, most of the students were Jewish. From that day to this, Charlie has been trying to understand the Nazis and the Jews. These soul-searching obsessions that we discussed then, he still writes about.

Our speculations about the meaning of life were very exciting and meaningful to us. Though they are now almost buried under many other considerations, I think that in some deep ways they still inform our artwork.

Charlie's mother looked like Marlene Dietrich and worked as a makeup artist for actors such as Arthur Godfrey. Charlie was unusually handsome and mature-looking. His mother would dress him up in a suit and take him with her to bars, where he would light her cigarettes for her.

One afternoon when Charlie and I were walking through Rockefeller Center showing off, he said he'd demonstrate how to pick up a man. As we ambled along, a fellow passed us, then stopped to look in a store window. "Stay here," Charlie said. He walked past the stranger and then stopped to look in another store window. Soon they were both looking in a third window. The man started a conversation, but Charlie excused himself, joined me, and said, "See?"

I was impressed and a bit shocked by Charlie's savoir faire. I

was so innocent of the real world while Haseloff was already out there, perhaps almost out of control, but living, surviving. Charlie rented a room, found work. Among other things he was an artist's model, both at the League and privately, most notably for Salvador Dali.

Haseloff was a tortured Romantic. Anachronistically, his paintings and drawings were Baroque in style; his favorite artist was El Greco. Haseloff was unable to resolve his paintings, which were dark and turgid. He'd paint over them or tear them up. I watched him kick a hole in one of them that was painted on masonite. The next time I came over to his dark little apartment, I saw that he had cut away the face from the damaged panel and glued it to another piece of masonite on which he continued to paint. Haseloff's creative struggles were like the German artist Frenhofer in Balzac's story *The Unknown Masterpiece*.

While still in his twenties, Charlie gave up art. I was very disappointed, and have always thought it was a big mistake. He became a writer, while working a clerical day job at City College. Back when Soho was an exciting subculture, Haseloff gave readings of his poetry and printed broadsides. Later he switched to prose, in particular an idiosyncratic mixture of allegory and satire. In recent years he has been struggling through innumerable revisions of a parable called Little Red Riding Bra.

For well over thirty years, Haseloff has lived in a loft on Mercer Street, perhaps the only one in the building that has not been gentrified. Vast and gloomy, the deep dark interior is something between a garbage dump and a museum. Charlie retrieves from the streets of Soho hundreds of abandoned objects and hauls them up the five steep flights. This detritus, often unidentifiable, has been hung along the brick walls, piled on the splintery wood floor, or displayed on various reclaimed tables and makeshift stands. There are also constructions made by his ex-wife and son, composed of more debris.

To my mind, Charles Haseloff has always had the heart and mind of an artist. He has just not been able to find the appropriate form of expression, one that would satisfy him or make sense to the public.

Admired Artists

Most of my friends at Music and Art, as well as many of our teachers and parents, belonged to a decidedly left-wing Jewish milieu. We were interested in the Regionalists and Social Realists, artists from the Depression years: Ben Shahn, Anton Refregier, Philip Evergood, Jacob Lawrence, Charles White, William Gropper, Reginald Marsh, Thomas Hart Benton, the Soyer brothers, David Burliuk, and the Mexican muralists.

We thought of these artists as humanistic, meaning they cared about social problems: racism, poverty, Fascism. We were also influenced by the School of Paris. This meant first of all the four Jews—Chagall, Modigliani, Soutine, and Pascin. Then there were French Parisians: Roualt, Derain, Vlaminck, Utrillo, Segonzac, Matisse, Dufy, Vuillard, Bonnard. We favored Picasso's Blue and Pink periods and Braque's late work. Ah, those gay Parisians, they made painting seem so simple and yet so full of life.

Parisian artists may have seemed gay in the old sense of the word, but between the wars there was an undercurrent of tension. The French-born artists were chauvinistic and resented the success of artists from other countries. For instance, Vlaminck wrote hateful statements against Picasso and the foreign Jewish artists in Paris.

We also loved the German Expressionists, lumped indiscriminately together with the later New Objectivity group that included George Grosz, Otto Dix, and Käthe Kollwitz. At Music and Art, we found German Expressionism even easier to imitate than School of Paris. Kirchner, Kokoshka, Kandinsky, Klee, Franz Marc, and Ludwig Meidner—their angst mirrored our existential dissatisfaction with the stifling prosperity of the Truman and Eisenhower years.

In our youthful enthusiasm, we weren't aware that Abstract Expressionism and formalist aesthetics were already relegating most of our favorite artists to second-class status or near oblivion. Admittedly, there are banal aspects to the Regionalists, Social Realists, School of Paris, and German Expressionists. But I feel that they had an engagement, a life force that has been sadly lacking in art since the Second World War.

Museums Then

The Whitney

The Whitney Museum of American Art was on 8th Street. It had been Gertrude Whitney's studio, converted from a couple of townhouses. Now it was a maze of large and small rooms on different levels. When the Whitney moved uptown, the 8th Street space was taken over by the International Youth Hostel.

The painting I remember most clearly was a Charles Burchfield watercolor of a looming industrial structure reflected in a stagnant pool. I also remember a little room like a chapel, a memorial to Gertrude Whitney. It contained an idealistic nude that she had sculpted, a dedicatory plaque, and easy chairs. People sat there and smoked.

Gertrude Whitney, an heiress, collected other artists' work and used her expanded studio to give them exhibits. The core of her collection consisted of works by American scene painters.

Bob Smithson and I attended the Whitney Annuals with avid curiosity, first at the 8th Street location and soon after on 64th Street. The Whitney had taken over a building that was behind the Museum of Modern Art, appropriately connected by an obscure passageway.

We would dash from picture to picture, guessing the painters before reading the labels. We strained our brains to interpret the currents and countercurrents. One trend was clear: Abstract art was increasingly prevalent. Each Annual had fewer Realists. Some of my favorites hung in there: Raphael Soyer, Edward Hopper, Ben Shahn, Philip Evergood, and three new "magic realists" who painted with egg tempera: Jared French, Paul Cadmus, and George Tooker.

The Guggenheim

The Guggenheim Museum of Non-Objective Art was in a small Fifth Avenue mansion, a few blocks down from its current site. I liked the consistency and purity of the collection. There was no imagery, no reference to the things of the world. Once, contemplating a Mondrian, I lay back on one of those plush upholstered benches. As usual, nobody was around. I sank into a trancelike meditation. Since that experience, I've retained a reluctant respect for what were called "purist" paintings.

Perhaps this quirk in my taste goes back to Mrs. Ridgeway's Bauhaus design lessons. In art it's good to reduce the elements to their essence. However, when minimal art came along later, I did not experience the same transcendental feelings. In their case, I usually felt that less was less.

The MOMA

In the 1950s, the Museum of Modern Art had several rooms of Realist paintings. The paintings were popular. Pavel Tchelitchew's *Hide and Seek* was the public's favorite painting in the museum. It was damaged, they said, along with a Monet of water lilies, in a fire in the 1960s. Both were restored. The Monet is always on view, but where is the Tchelitchew?

Some of the other Realist paintings were: Peter Blume's *The Eternal City* (depicting a jack-in-the-box with the head of Mussolini), Andrew Wyeth's *Christina's World*, Edward Hopper's inside of a movie theatre, Clarence Carter's women picking up coal along the railroad tracks, Ben Shahn's dead soldier on the beach, and his welders, Diego Rivera's *Zapata*, Siquieros' crying baby, Frida Kahlo's self-portrait with cut hair all around her, Otto Dix's portrait of his parents, and his doctor in his office, George Grosz' portrait of a hunchback, and Balthus' portrait of Derain with a model.

These are hardly the paintings that would come to mind for people nowadays when they think of the permanent collection. Permanent in

what sense? The MOMA traded out one of Kuniyoshi's best paintings for a slight sketch on a napkin by Picasso that related to his *Les Demoiselles d'Avignon.*

Though I favored the Realists, I taught myself to identify every work of art in the collection by sight. I thought that if I were to bring a date to the museum, this knowledge would be impressive.

The Met

The Metropolitan Museum of Art was very big, but not half the size that it is now. The City finally had to pass a law that it could no longer encroach on Central Park.

Back then it was never crowded, far from it. I remember a large sitting room with views of the park. Visitors were encouraged to rest and smoke. There were red plush chairs and settees like those in Degas' and Lautrec's paintings of whorehouses. For a long time the walls were hung with humorous paintings of epicurean cardinals by Vibert. Another year, there were Corots, mostly nudes in the landscape.

That smoking room was probably as close as a museum could get to how nineteenth-century collectors hung their art. It could never happen now.

I liked to wander at random through the picture galleries, finishing the day in the American wing, which back then was hidden behind the armor rooms.

The Art Galleries

There were only about twenty galleries, all on 57th Street. They were in ramshackle little buildings, usually up long, narrow flights of stairs. My favorites were the A.C.A. and Midtown. The gallery people usually ignored me, and I felt too insignificant to say anything. Once, an elegant gallery attendant did engage me in conversation while I was looking at the geometrical abstractions of I. Rice Pereira. Elucidating her works, he segued into a discussion of aesthetics. Professing that beauty and function were synonymous, he asserted, "A Grecian urn and a Boston bean pot are equally beautiful."

The man looked like an aesthete, but now that I think about it, perhaps he was a Marxist.

Art For The Public

I dreamed of one day exhibiting my paintings in one or another of those galleries. It was a simple little art world, and I imagined that I would fit in sooner or later.

In my student days, the art world was circumscribed, highly specialized. Who would have thought that art would become a media extravaganza?

While studying at the Boston Museum School, I would often take my lunch break next door in a small restaurant that was tucked away in the back of the sprawling Boston Museum. It was never crowded, the food was inexpensive, the service was friendly, and there were white tablecloths. Best of all, above the tables were hung Monet paintings—real ones. Never Again.

Here's another example of how art has become precious: I spent a summer working in the only gallery in Stonington, Connecticut, a gentrified fishing village. There was a little art center near the beach, where they showed foreign films. One afternoon, I went to see Eisenstein's *Battleship Potemkin*. There was no one there except for a few teenagers and myself. A few minutes into the film, the teenagers left. After it was over, I stopped in the lobby to look at the traveling art exhibit—pop art, still a novelty. In the middle of the room was Rauschenberg's stuffed goat with a tire around its waist. There was nobody around. I fought back an urge to smash it. Some years later at auction it fetched millions of dollars.

Why did art become increasingly iconic and exhibition areas take on auras of sanctity? This is a question for sociologists and economists.

Teen Bohemia

We young art students were sustained by absurdly romantic notions of artists' lives, a bohemianism that emanated from the Parisian art world. Our Paris was Greenwich Village. In the coffee houses, we were surrounded by the most creative-looking types imaginable, all seemingly deep into discussions about culture and society. Looking back, it amazes me that all those creative people had time to sit around so much in coffee houses and bars.

Our disgust with the philistinism of the 1950s was reinforced by the popularity of the post-Impressionists: Van Gogh, Cezanne, Gauguin, Lautrec. They were idolized as artists, but wasn't it also because they were so shockingly antisocial?

By the time Smithson and I were seventeen, we had abandoned the coffee houses, preferring bars where artists hung out. Most prevalent was the Cedar Bar. Legal drinking age was 18, but the management probably didn't expect that kids would have any interest in being there. The Cedar was in itself innocuous looking. The predominantly male clientele wore suits, or at least sport jackets, and ties. Nevertheless, the milling crowd of artists and hangers-on radiated energy, even a manic wildness.

This had been, and to some degree was still, the watering hole of Pollock, De Kooning, and company. I was introduced to Franz Kline, but he was too drunk to focus. The clientele were mostly second-generation Abstract Expressionists.

On weekend nights, Bob and I followed the crowd as they migrated from the Cedar Bar to various loft parties. These were cavernous dark rooms full of swarming figures dancing, drinking, and shouting over blaring jazz. Smithson and I assiduously mixed with the action painters in their 10th Street studios, their galleries, and at their Artists' Club. No

one noticed us. We also hung out at the White Horse tavern where Dylan Thomas had recently had his last drinks, at the Half Note where Lennie Tristano was at the piano, and at the Five Spot, where I listened to Monk, Coltrane, and even Larry Rivers. I sensed the creative energy of the era more in the jazz than in the painting.

Robert Smithson Again

In my high school years, I lived with my father and stepmother and their three young children in a big sprawling apartment on the corner of 99th Street and Riverside Drive. A Jewish neighborhood, it was being absorbed by Harlem.

Just inside the front door, my room was separated from the other bedrooms by the living room and dining room, which were down a long hallway and had views of the Hudson River. I was closer to the maid's room.

Bob and I would sequester ourselves in my room and play our favorite records: The Rite of Spring, Symphonie Mechanique, and Carmina Burana. Borrowing pots and pans from the kitchen, we would accompany the music, banging and howling.

Smithson once took me on the bus to New Jersey to visit his parents' home, a lower-middle-class tract house furnished, I thought, without taste. They weren't home. Sensing my uneasiness at the lack of aesthetic niceties, Bob said that his grandfather had been a master woodworker—had, in fact, carved moldings around the ceilings of the Metropolitan Museum.

He didn't tell me anything about his parents, except that they had had a child before him who died in infancy, and whose namesake Bob was.

We spent that afternoon exploring Bob's favorite place, an abandoned quarry not far from his parents' house. This quarry was a major influence on his future artwork.

The summer of 1958, Smithson and I hitchhiked westward, combining our fascination for Kerouac's *On the Road* with Bob's desire to see Canyon de Chelly in Northern New Mexico.

Many artists at that time, Pollock among them, were trying to

connect with a primitive atavism that they found in Native American culture. In Smithson's case this was combined with his fascination with earth formations.

We made it to the rim of the canyon, where intermittent signs along the road forbade descent. We walked along the road until we found an obscure spot, then scrambled over the edge and worked our way down the steep incline. We followed the river, exploring the meandering canyon floor for two days. Often the river shifted from one canyon wall to the other, forcing us to wade across. Occasionally, the mud was like quicksand. It pulled our shoes off our feet. A couple of times we sank to our knees and had to lie down in the mud and wriggle out, laughing hysterically.

Eventually we turned a bend and came across the famous view of the ancient adobe buildings set into the side of a cliff. There was a wide path, a kind of esplanade staircase. The tourists were trooping up and down, and they gaped in wonder at us, two desert rats who came out of nowhere.

I had a small sketchbook in my backpack, and I did a series of drawings of our adventures, a kind of comic book sequence. Some time later I threw it away after Smithson and I had a falling out.

Smithson scholars, of whom there are many, would have found those sketches amusing. Not long ago the Smithsonian Portrait Gallery in Washington, D.C. bought two portraits that I drew, front and profile, of Smithson's reptilian head, in 1955. They paid ten times as much as I had been asking for them.

After two years at Brandeis University in Waltham, Massachusetts, I returned to New York in 1959. Smithson and I found a second-floor apartment over a synagogue on Hester Street, deep into the Lower East Side. We only paid $17 a month, with the understanding that we would turn the synagogue lights on and off during Sabbath. Bob made the arrangements, but scoffed at the archaic accommodation.

We hoped to have a communal living and working space, like the German Expressionists in Berlin, or Van Gogh and Gauguin in Arles.

In the Village, I met a lovely girl named Billy, an aspiring writer.

I invited her to come live with us, and she did. How delightful our little utopia was becoming. Smithson took a strong dislike to her and did not hide it. Billy left.

Then Bob brought into the establishment a small nondescript young man named Bob Israel, who followed Smithson around like a puppy.

Smithson's and my ideas about art had begun to diverge. He pursued the current avant-garde ideas. I wanted to master figure painting and do work aligned to Social Realism.

A couple of months into our utopian experiment, we were evicted by the members of the synagogue downstairs. Smithson had neglected his duties as Sabbath goy.

Smithson found a moldy two-room walkup on Madison Avenue, in the upper section where the street was no longer fashionable. He hung hundreds of strings and ribbons from the ceiling and painted agitated patterns on the walls. I don't know if he lived there, it was more that he tried to get art-world people to come uptown to experience the space.

He was influenced by Kurt Schwitters. The space Bob transformed had a wild abandon, something like the happenings that erupted a few years later.

We had gone our separate ways and lost touch. I met him only once again, when I wrote a review of a project he was working on. It was in a big, bleak loft. On the floor was laid out a cardboard city that Bob had fabricated with a group of children, working under some kind of grant. Quite imaginative, it was like a Red Grooms, but grittier.

Skowhegan School Of Art

In the summer of 1957 I bought an old motorcycle for fifty bucks and found my way from Boston to Skowhegan, Maine. I had been given a full scholarship on the merit of one of my sketchbooks. I was told, off the record, that the money came from Ben Shahn. This was quite an honor. Shahn was one of America's best-known artists and I admired his Social Realist subjects.

The Skowhegan students were older than me, except for Jerome Witkin, who, at 17, was just graduating from Music and Art. We were friends, and I had visited his home in Brooklyn, where I'd met his twin brother Joel, who was already into photography. Even then they were both fascinated by the macabre.

Skowhegan was very competitive. The sixty summer students were said to be the best graduates from art schools around the country. Skowhegan was perceived as a halfway house on the way to their art careers. The idea was to put a stew of artists into a pressure cooker so that they would be ready sooner.

Besides the core teachers, there were specially invited big-name teachers and then there were even bigger-name visiting lecturers.

All the faculty and students were expected to attend the nerve-wracking weekly critiques on Saturday mornings.

Some students were praised, others faulted. It was all against one and one against all, quite different from the benevolent critiques that John Groth gave at the League.

There was a student from the South who dressed conservatively in a white jacket and tie and had an aloof, withdrawn manner. He presented two frescoes of life-sized standing nudes, done in a quattrocento style.

We ridiculed his efforts, which seemed hopelessly old-fashioned. That winter I heard that he committed suicide.

Looking back forty years, I now think he was one of the most interesting artists there, and have been making similar attempts to adopt the Florentine style, though in egg tempera rather than fresco.

One of the guest teachers was George Grosz. He was old, round-faced, pot-bellied, always smoking a cigar, alcoholic, bemused, and cynical. He liked to advise that if we wanted to be successful artists we should climb up on ladders and throw buckets of paint on canvases. I couldn't tell if he was being ironic in the Dada spirit of his youthful Berlin years, or indifferent, burned out.

I painted a cartoony head, a cigarette dangling from its lips. I put it upside-down in the lineup of the Saturday critique. Everybody was disgusted with me. Only Grosz had a few kind words, saying that I was searching, questioning.

That winter, Grosz moved back to Berlin. He was found dead at the bottom of the stairs to his flat. He had come home drunk the night before, and apparently his wife had locked him out.

At Skowhegan my work was more influenced by Modern Art than at any other time in my life. I experimented with Primitivism and Surrealism. Most of the other students were painting Naturalistically, some slightly Expressionistically. Many were inspired by the glorious landscape all around us.

Having hung out with Smithson in the Village, frequenting the Cedar Bar, I tried to accept Modern Art. A couple of years later, painting from the model every day with Raphael Soyer, I recommitted to my earlier love of Realism.

At the end of the Skowhegan summer, there was a talent show with humorous skits. One of the regular teachers, Sidney Simon, came onstage wearing a motorcycle jacket and acting sulky and drunkenly confused. The character he was playing was supposed to be me.

One of the guest lecturers was Isabel Bishop, an artist who was well known in the 1930s for her paintings of shop girls and vagrants around Union Square in New York City. She discussed the concept that

a painting could be like a stage, what she called "box space." This was a heretical idea in the 1950s, when Clement Greenberg was preaching the gospel of honoring the picture plane. Bishop was analyzing what John Groth had taught instinctively. I had not realized that there was a tradition of classical aesthetics of controlled structures in space, exemplified by Poussin's paintings. Modern Art was mostly elucidated by formalist theories; there should be no illusionism. Abstract shapes should not give the illusion of receding in space, which would be "poking a hole in the picture plane." Greenberg went even further, claiming that the physical materials of art are tantamount: colored paint, a flat surface. He preferred an overall pattern to a focused composition.

Another guest speaker, very intimidating, was David Smith. Dressed as a laborer, he bragged about the strenuousness of welding. Like most of the Abstract Expressionists, he adopted a hard-living, macho, anti-intellectual manner that I found distasteful.

Cummington School Of The Arts

The next three summers I spent at a less prestigious but more enjoyable art camp in Massachusetts. Music was Cummington's strong suit; painting came second. There were also a few poetry students.

I found the music inspiring. In our barn dorm, I could hear the violins, violas, and cellos practicing behind the wood partitions. I liked the soothing sounds and was inspired by the musicians' dedication.

On Sundays we all dressed up for the outdoor concerts. Behind our rows of chairs were some freestanding walls where we hung the paintings we'd just finished.

After my first time at Cummington, I arranged for two of my closest friends, Dick Stroud and Robert Cenedella, to come up the next summer.

The director of Cummington, an artist named Adelaide Sproul, had a commanding presence while her husband, Hal, was a silent, gaunt New Englander who played the cello and drank.

Trying my best to paint Realistically, I went out to do landscapes. "Why paint a sky blue?" Adelaide criticized. "It's predictable, boring. Try to find another color."

Eugene Delacroix wrote: "Nature is an alphabet. It's what the artist does with the letters." But, au contraire, I was becoming convinced that art can never surpass or even equal nature. Every time I changed something that I saw, I felt that I had substituted a conventional configuration for a more subtle one.

I concentrated intensely on painting some hollyhocks and, after a long struggle, was pleased with the result. Adelaide said, "Hollyhocks are common weeds. Can't you find something more inspiring to paint?"

One of the other artists found a dead bird and invited me to join

him. We laid it on a little table in the studio barn. A couple of hours after we had started our paintings, I had the feeling that the bird had moved ever so slightly. I asked my friend if he noticed anything. No. Again I sensed a slight movement. This time he noticed it too. On closer inspection, we saw that the bird was full of maggots. That was one painting I never finished.

One rainy day I had a cold, felt feverish, but thought I would try to paint anyway. In the corner of the studio was an abandoned chair. Its back had a broken rung. I painted that chair, persevering though I felt faint. It was the best painting I did that summer.

Perhaps working feverishly enables one to bypass reservations and inhibitions. However, this way lies madness. Van Gogh did an empty chair. It is a subject that has poignancy. I have painted a number of chairs since, and sold them too.

Towards the end of the last summer I was at Cummington, I took my egg temperas and French easel up the hill to an old abandoned graveyard and painted a series of little panels depicting the worn tombstones under the trees. Not long ago, I was reading about the photographer Diane Arbus and discovered that she had gone to Cummington a few years before I did, and that that graveyard had been her favorite spot.

On the subject of egg tempera, using this medium outdoors is next to impossible. Each color must be mixed on the spot, blending powdered pigment, egg yolk and water. The paint, in a palette made up of little cups, dries in minutes. It takes perseverance. Egg tempera was used by Medieval and early Renaissance painters and replaced by oil paint in the high Renaissance of the 1500s. The medium had a limited revival in the late nineteenth century, after Cennini's 1400 treatise was translated into English. Many modern Realist painters have used egg tempera, such as Andrew Wyeth, Reginald March, Paul Cadmus, and George Tooker.

Brandeis University

The two years that I was at Brandeis, 1958-1960, I would take the train down to New York as often as I could. During my sophomore year, I arranged my schedule so that all my classes met on Monday, Wednesday, and Thursday. By cutting the Thursday sessions, I could be in New York four days a week. My grades were all Cs. I consoled myself with something I'd read that said these were "a gentleman's marks."

The painting teacher at Brandeis was Mitchell Siporin, a pudgy little man in ill-fitting suit and tie. I couldn't imagine that he'd ever painted anything. I have since come across reproductions of his murals, depictions of huddled, displaced persons surrounded by ruins and debris. They are painted in a simplified bold manner, some in true fresco. As it turns out, Siporin was one of the best Chicago WPA artists.

I was a blindly self-centered art student, impervious to my teachers' qualities even when they were exactly what I needed.

Brandeis had only been in existence for eight years. Our art studio was in a corner of the gym. Taking breaks from painting, I'd lift weights. Some jocks asked if I would put down my brushes and join them, they needed another player for their basketball game. I was ignorant of the procedure, but they were sure I could do it. The experiment was not a success, and I've never played since.

One of Siporin's duties was to look after paintings that had been donated to Brandeis. Together we hung the paintings in the common rooms of various dorms. Siporin and I joked about this more or less worthless stuff having been donated for tax write-offs. Among the donated paintings, I remember a cubist still life by Alfred Maurer, a Milton Avery, and two early De Koonings.

Today the Maurer and the Avery would probably fetch over half-a-million each and the De Koonings would be in the millions.

Not happy with the stylistic confusion that I had been going through, I decided I would try to make up a figurative painting. It would be simple—two nude women standing by a bed. I couldn't do it. I just didn't have the ability to construct the figures.

This inhibited my desire to be a Realist. I continued fumbling around with Symbolism.

Arnold Hauser

Professor Hauser, who was teaching nineteenth-century French art, was a haughty and pedantic German in spite of having written the first Marxist survey of Art History.

Hauser was put off by my long hair, black clothes, and leather jacket and acted like I didn't exist. One day before class I was in the bathroom when he happened to come in. "How can you dress like that?" Hauser suddenly said. "What's wrong with you? So dirty."

At the end of the semester we had to write papers. Hauser assigned Manet to me. Worst luck—I had no feeling for Manet. His paintings appeared to me to be arbitrary, detached, and amateurish. I found a book in the Brandeis library, *Manet and His Critics*. It contained copious examples of writings by his contemporaries that lambasted him, supposedly misunderstanding his genius. I heartily agreed with most of their criticisms, though obviously I wasn't supposed to say that. So I waffled around, trying to point out Manet's lack of affect, in effect admitting how hard I found it to relate to his work. Surprisingly, Hauser gave me an A.

Leo Bronstein

The other art history teacher, Bronstein, was more popular than Houser. He had a little coterie of groupies. An effusive aesthete, Bronstein's emotive outpourings tended towards incoherence. He would

gush on excitedly about the redness of the red, the angelness of the angels. He loved El Greco.

I thought of Bronstein as a Jewish Walter Pater. Pater was a nineteenth-century English don at Oxford whose overly precious essays were forerunners of art for art's sake, Symbolism, and the decadents. Pater is now chiefly remembered for having written a paragraph of extraordinary purple prose about the Mona Lisa.

Bronstein Again

I encountered Leo Bronstein a few years later in the most unlikely of circumstances, at a particularly intense moment in my life. I was a student at the Boston Museum School. A friend of mine, Susan, was pregnant by another friend, Dick Stroud.

Susan and I took a train to Washington, D.C., where we'd arranged for her to have an illegal abortion by a Hungarian doctor. We arrived at the train station a few hours before her appointment, so we walked, not a long distance, to the National Gallery. Wandering through the fine collection of early Italian art, Susan and I came to a small round room that was almost like a chapel. The centerpiece was a large Madonna and child by Raphael. This painting, which in the nineteenth century was one of the most admired pictures in the world, is an idealized, almost saccharine vision of the mother and child. Leo Bronstein hurried into the room. Oblivious to us, he dashed forward and then stood motionless and rapt before the Raphael. After a long silence, he moaned ecstatically. Susan and I backed out of the room, without Bronstein noticing.

As arranged, we were picked up at the Museum entrance and driven to the doctor's office, in the lower level of a suburban house. In the waiting room we could hear a child's birthday party overhead. After the operation, the assistant drove us to our hotel. I sat up front, Susan, who felt queasy, in the back next to the man's fedora. She lost control and threw up in his hat.

In the Back Streets of Cambridge

I've let my story get ahead of itself. Let us return to my sophomore year at Brandeis, 1957-1958. After the summer at Skowhegan I moved to Cambridge to share an apartment with Murray Reich, an older artist I'd met at Skowhegan. Murray, though from a poor Brooklyn Jewish family, looked like one of the emaciated Bohemians in Picasso's Blue period. He painted somewhat like Arshile Gorky.

We lived on the second floor of what had been a family house. Murray paid more rent than I did, as I had a tiny bedroom that was crammed behind the stairwell, with its window facing the street. The stairs came right up into our apartment, while the downstairs tenants, a couple of lesbians, could close off their space with doors.

A block from Harvard Square, there was a coffee house whose proprietor offered to hang Murray's paintings. Murray generously offered to share the wall space with me. This was to be the first time I exhibited. I'd never even framed a picture. Murray showed me how to nail wood stripping around the edges of my canvases.

I felt that my life as an artist was beginning. To this day, I am pleased to hang my paintings in coffee houses and restaurants. Many artists feel this is too common, but I like it for that very reason. The surroundings create a bohemian ambiance such as might have existed in Paris or Greenwich Village.

A Traumatic Incident

During my very first days at Brandeis, initiation week, I'd met a wonderful girl named Joanna White, and we had been together since. Now, at the end of our sophomore year, we decided to go to the spring prom, which was held on campus on a Saturday night. We got all dressed up, Joanna in one of those stiff 1950s gowns, and me in my Brooks Brothers suit. Joanna and I foxtrotted, bunny hopped, and twisted until after midnight. Exhausted, we drove back to Cambridge, as Joanna had signed out of her dorm for the weekend.

I had no curtains in my little room, so I covered the window with a painting. It was one of several paintings by Bob Smithson that I had stacked against the wall. The subject was an emaciated hag, standing naked in front of a shack. Defiantly, I turned it facing out.

Joanna and I were awakened by several policemen ordering us to get up. They looked enormous looming in the doorway. The girls who lived downstairs, one of whose father was a cop, had let them in.

They waited outside the door just long enough for Joanna and me to pull on our clothes, clammy with dried sweat from the night before. Then the policemen filled my room. They removed the offending painting from the window, which had so upset the churchgoers passing by that Sunday morning. They poked through the other Smithsons and some of my drawings of nudes. They questioned, lectured, and intimidated us, even making Joanna call her mother, as we were under 21. Thankfully, her mother wasn't home.

"The young lady can't stay here. She'll have to leave. You're breaking the law." They escorted us out into the street. They watched as we walked down the street and around the corner, seeking refuge in a friend's apartment.

The shame of the police raid undermined my relationship with Joanna. I left Brandeis and went back to the New York art scene.

Raphael Soyer

I decided to do my next two undergraduate years at the New School for Social Research. Mornings, 9 to 12, I took Raphael Soyer's figure painting class. I monitored Soyer's class. Besides taking attendance, I timed the poses and looked after the models. Particularly, I inserted bits of foam rubber between their tender parts and the hard model stand. Academic classes were in the evenings. None of this cost me anything, because the school had a lecture system of adult education, and I collected the class tickets.

I was finally embarking on my lifelong quest to be able to paint the nude (for the past fifty-five years, I have been running life-drawing sessions.)

At the New School, as before at Brandeis, there was no art major. Colleges in those days still had standards, hesitating to consider applied art as a serious academic subject. My major was literature. Painting for three hours every day for two years gained me only twelve credits.

Soyer was more successful than most of his compatriots of the Depression era, practically the only one who still got his paintings into the Whitney annuals. I don't know why they accepted his work, especially considering that he was outspoken in his condemnation of the Abstract Expressionist artists. Perhaps one reason was that Soyer was no longer painting Social subject matter. His subjects were young women, clothed or nude, and occasional informal portraits of other artists and literary figures, including some beatniks.

I thought that Soyer was a good artist, but he was limited as a teacher. My desire was to paint a literal depiction of what was in front of me. In Soyer's class this was usually a bored, dumpy, naked woman who would slump and sag as the weeklong pose dragged on. Raphael

Soyer came in on Tuesdays and Thursdays. He tried to discourage us from using beige flesh tones, to make us see warms and cools, yellows, greens, and purples. On Thursdays he would admonish that our paintings had gone dead, they were overworked, we should brush on a layer of loose fresh strokes to liven them up.

Surely, flesh is most often beige. But too many tans and browns become leathery. Since Impressionism, most artists exaggerate colors and brush-strokes. However, almost all the great figure paintings from the Renaissance through the nineteenth century depict beige skin and have smooth surfaces.

That was about it for Soyer's teaching. No underpainting techniques, no anatomy, no lessons in shading, no concepts of structure or composition.

If we asked for help, Soyer might point out that the head was too big, the feet too small, or the edges too hard. Sometimes he would take the brush and make changes. There were students who dreaded this, while others requested it. None ever changed what Soyer had touched.

In my opinion, learning is a collaborative process. The student should find an artist whose work he admires and then learn what this teacher knows. Ideally, the student should work up the painting to respond to the teacher's corrections. If the student cannot or does not want to imitate his teacher, then he should modify the corrections to blend with his own style.

Soyer liked to say that we shouldn't make our pictures too pretty. He felt that his own paintings were unsentimental and honest. This baffled me, as I could see a saccharine element in his countless depictions of young women. I wondered if he was unconsciously comparing his work to that of his twin brother, Moses, whose paintings were slightly more generic, less Naturalistic.

There was a funny old guy in our class, twice Soyer's height, with bulging eyes and long strands of hair plastered over his bald head, and a pot belly. He painted imitation Soyers, sloppy and garish. The students were mostly elderly and sickly, and the studio was overheated and full of paint fumes and cigarette smoke. Whenever anybody sneezed, which

was every few minutes, this funny old character would call out, "Goes in tight!"

Raphael Soyer's conversation frequently came around to the displacement of the Realist artists by the Abstract Expressionists. He considered Philip Guston, who had gone over to their side, a traitor, a collaborator, a scab. If he saw Guston coming down the street he would cross to the other side, he said.

Guston's youthful work in the 1940s was a powerfully engaged second-generation Social Realism. Pollock, a friend of his, taunted him and he switched a little later to Abstract Expressionism. Much later in his life he developed a third, more personal style that combined his early subject matter with his loose painterly style.

While I was studying with Soyer, I hired a model for the first time—Patty Mushinsky. (Soyer depicted her prominently in a street scene that is on the cover of the big coffee-table art book published by Abrams.) While Patty was posing in my studio, she told me about the artist she was living with and eventually invited me to come to dinner. I went, and she introduced me to Claes Oldenberg. The first thing I saw was a big canvas on which Claes had painted Patty several times, naked except for her black stockings. It was a bit like a Pascin.

Their apartment, on the East side, was cluttered with funny Dadaesque objects. "Ray guns" were scattered everywhere, found or manipulated L-shaped detritus.

Before I took my leave, Claes brought out a little handmade book that he had fabricated. There was a drawing of a man on the first page; then the book folded out accordion-style to about five feet long. The man's penis extended the entire length, periodically propped up by various characters and objects.

As I left, I said, "Claes, you should keep painting and not get too caught up with these whimsical things." (Some art critic I was!)

The Realist Protest

A protest was being organized against the Museum of Modern Art because of its exclusion of Realism. The artists who backed it were the Soyer brothers, Jack Levine, Reginald Marsh, Edward Hopper, and John Koch. They published a short-lived magazine called *The Realist*, which only lasted for two issues. Now, afraid to use their own names, they were encouraging their students and other young artists to picket the museum.

I went to a couple of meetings. Since so many artists prided themselves on being non-verbal, it was decided that I would write our pamphlet. (See next page.)

Our demonstration did not stir up controversy. I doubt that it could have, even if those older Realists had come forth. At that time, the late 1950s, the Realists were considered hopelessly old-fashioned and disturbingly leftist. European Modernists and, even more, American Abstract Expressionists, dominated the art scene.

The issues of Social Realism versus Abstract Expressionism are too complex to go into here. I have written a separate diatribe on this subject titled *Why I Hate Modern Art*.

PROTEST

AGAINST THE MUSEUM OF MODERN ART

"Art can occupy a central place in the life of the modern world only in-so-far as it can be ap-plied to things the majority of people are intimately aware of."

From Mr. A. Packard's 1938 report to the Board of Trustees, on the then proposed Museum of Modern Art.

"As the Museum of Modern Art is a living Museum, not a collection of curios and interesting objects it can, therefore, become an integral part of our democratic institutions."

From President F. D. Roosevelt's 1939 address commemorating the opening of the Museum of Modern Art.

********** ********** **********

THE MUSEUM OF MODERN ART

Has deteriorated into an institution for the dilettante;

has become a club of the initiated elite; which, along with favored galleries, artificially stimulates public interest, and by so doing encourages artists to execute absurdities for the entertainment of this special public;

has given excessive praise to limited technical experiments and the effusions of self-indulgence, calling these things great cultural advances;

has ignored vital contemporary schools of art in all countries whose diverse interpretations of life are not in keeping with its unnatural view of the world;

has attempted to elevate handicrafts, industrial design, and children's art to the highest forms of human endeavor;

has developed the public image of the painter as a madly inspired child, rather than an adult human being;

has, by all its policies and propaganda, deprived the public of a natural response to the art on its walls.

* * * * * *

TO STIFLE ART by indifference, calculation and ridicule is a betrayal of the dignity of man.

It is time to protest against this continuing insult to the artist and all men; to rebel against the Museum's unfair practices; to refuse the prostitution that they require; and to demand a change in its policies.

DEMONSTRATION

organized by artists who believe in the above statement will take place in front of the

MUSEUM OF MODERN ART, 11 WEST 53rd STREET, SUNDAY, APRIL 24, AT 2:00 P.M.

JOIN THE PROTEST

For further information contact: John Dobbs 45 East 7th St. AL 4-1532
 Daniel Brown 182 Avenue A OR 7-7935

John Koch

Among those illustrious Realists behind our demonstration, only John Koch was not a familiar name. Koch was of their generation but his super-Realist paintings were just beginning to be noticed, first in group shows and then in one-man exhibitions at Kraushaar Gallery. Little catalogs of his work were circulating among Realist students.

Koch's paintings were depictions of his elegant lifestyle. He had a large suite in the El Dorado, a classy old twin-towered monolith on Central Park West. The Beaux Arts elevator opened right into his antiques-laden vestibule, which in turn opened onto a suite of rooms even more ostentatious than his paintings.

Koch gave me a tour, emphasizing the paintings hanging on the walls, which included a small Rubens oil of a saint's head looking upward in ecstasy, a biblical scene by Jan Steen, and a large, powerful cityscape by Belotti, Canaletto's brother-in-law.

In Koch's studio was a floor-to-ceiling Baroque depiction of a martyr twisting in rapture.

"Can you guess who painted that?"

"Venetian? The generation before Tiepolo?"

"Not a bad guess, but it's a Koch. I painted it after visiting Venice. I was carried away by Titian, Tintoretto, Veronese. I saw a huge Tintoretto that so overwhelmed me that, as I stood in front of it transfixed, I had an orgasm."

That was a conversation stopper. I was glad that my friend Bob Cenedella was with me.

On John Koch's easel was a nearly finished painting of a middle-aged businessman. It was surprisingly mediocre.

"A commission from Portraits Incorporated," Koch explained dismissively.

A gigantic framed mirror hung on the back wall of the studio, its glass antiqued to a slightly silvery hue. Adjacent was a large painting that depicted a cocktail party taking place right where we were standing, in front of that very mirror. The scene included the grand piano surrounded by perhaps a dozen elegant guests. These included Reginald Marsh and the Soyer twins, all looking unbelievably soigné.

I had brought a painting to show Koch. It was a reclining figure, clothed, a portrait of my lovely friend Hila Newman. I had been working on it for months. Koch praised it, only gently criticizing the way I'd depicted the reflected light on the floor, "which, as you know, is one of my specialties. May I inquire what price you have set on this lovely painting?"

"Three hundred dollars," I ventured wildly.

"I'd like to buy it."

As we were leaving, Koch invited Cenedella and me to a dinner party that he was planning to give for young artists.

On the appointed day, Bob and I arrived and found that there were about twenty young artists, mostly students of Frank Mason. Mason was perhaps the most retarditaire maestro at the League. He and his students painted a murky, timeless, placeless figurative art, dark, turgid, and brushy.

Retarditaire is the opposite of avant-garde. These seekers after Rembrandt imitate his technical mannerisms. Whereas the Old Masters were acute observers, the modern imitators are blinded by formulaic conceptions. Some, such as David Leffel, do tenebrous self-portraits, complete with swollen noses and floppy black felt berets.

Frank Mason advocated Maroger medium, not then on the market. Devotees claimed it was the secret of the Masters. John Koch also used it, as did Reginald Marsh in his later work. (I preferred his egg temperas.) The Maroger formula included the dangerous process of boiling black lead to turn it into a dark amber gel. It was rumored that Frank Mason's mind had been affected by the poison fumes.

Koch's servant summoned the young artists to his studio before dinner and we formed a semicircle around the maestro. He sat at his easel arranging the colors on his palette. The panel he was about to paint on,

16" by 20", was primed a dark gray. Another servant came in carrying a silver salver on which was a slice of watermelon. He put the platter on a little antique table that stood beside Koch's easel. Koch painted from start to finish, in less than an hour, a marvelous rendition complete with the highlights on the glistening seeds.

I generally prefer slow, searching, even hesitant craftsmanship to virtuoso display, but Koch made me aware that the Old Masters might have painted much faster than I'd thought. I've read that Rubens could do a finished figure painting in a single sitting.

After the demonstration, passing through the living room on the way to the dining room, Koch paused to point out a little painting that he'd done of himself and his wife sitting on a small couch holding hands. "I painted it for my wife to celebrate our anniversary." He had given himself thicker hair and a stronger jaw than he actually had. She was depicted as pleasantly plump, but when I met her a moment later at dinner, I saw that he had taken off at least fifty pounds.

The anniversary picture startled me. I had assumed that Koch was homosexual. His paintings of interiors often included attractive men: butlers, maintenance men, models in his studio.

Butlers there were, waiting in the elegant dining room, adjusting our seats under us. They weren't as good looking as the ones in his paintings.

Koch's wife sat to his right, and I had the honor of being seated on his left. There were several courses, many refillings of wine glasses. About halfway through the meal, John Koch caressed my leg under the table. I shifted away uncomfortably, and he didn't repeat the gesture.

That evening was the last time I saw him. Some years later I heard that he had had a bad stroke, could no longer paint, and was in a wheelchair, moved around by his wife.

Poor John Koch. He was an excellent artist, very original for the period. He painted like a Dutch Master, but used personal subject matter. As far as I know, his work has been entirely overlooked.

My Attempts To Exhibit

After studying with Raphael Soyer, I began to take my paintings around, hoping to find a gallery. My favorite gallery was A.C.A. The painters were all leftists, even Communists. The director was Herman Baron, an unprepossessing fat little man with a cigar, just like a caricature of a capitalist.

I showed my portfolio to Mr. Baron. That was the first time I'd ever submitted my work to a gallery. He said no.

I continued to go to the A.C.A. to see the exhibitions. One day, Baron asked me if I had any new work.

"I left my portfolio in the hallway."

He laughed at that. "Bring it in and let me see."

"No, thank you." I wasn't ready to face another rejection.

My last summer in Cummington I had painted a series of graveyard landscapes in egg tempera. Back in Cambridge, I brought a stack of them into an obscure little gallery that I liked the looks of. I asked the manager if he would take a look. He assented, and I placed the small, unframed panels along the floor, leaning against the wall. After a long silence, this tall, well-dressed young man said that he liked them and would be willing to give me a show.

I went back a few days later to discuss the details. He said he had changed his mind.

I've never had a thick skin, nor have I practiced the power of positive thinking. At the time, I thought that those graveyard paintings had something special, but who knows? They have long since disappeared, along with all the other paintings that I did at Cummington.

In New York I applied for a few grants. The American Academy in Rome particularly excited my expectations, as I had often read about

promising young artists, such as Jacques-Louis David, who had gone to Rome to add the finishing touches to their years of training. The American Academy in Rome had its office in New York. I went over there with my slides. When I told the receptionist why I had come, she and two men who were in the office started laughing.

"Why are you laughing?"

They hesitated, then one of the men said, "Because you are so young and innocent."

To get a grant, an exhibit, a sale, the artist should try to know who he is targeting and know what they want.

Just off Madison Avenue a new gallery, Davidson, opened and, unlike most galleries in the 1960s, they were showing a group of young Realists. Several of their artists had gone to Music and Art High School a few years ahead of me. I left a portfolio of my paintings with the elegant receptionist and came back a few days later to be told politely that, while I had been rejected, when I had a new body of work they would be glad to look at it. After several years of repeated attempts, the receptionist said, "Please don't bring us your work anymore."

My father introduced me to a gallery owner named, oddly, Gertrude Stein. The visit was already awkward, as I felt there might have been something unmentioned between the owner and my father. Ms. Stein's gallery had a cool, contemporary ambience, not my scene. At my father's prompting I did return to show Gertrude Stein my little Social Realist egg temperas, which I was carrying in a shopping bag. In the glare of the gallery lights their matte surfaces appeared dull.

"Oh, I see," said Gertrude, "the dated style, the dusty surface, the paper bag; you're making a statement."

Despite these early farces, I have exhibited my paintings in galleries. Some I owned, others were run by friends, and a few even showed my work because they liked it.

I find that as one becomes familiar in the art scene, acquaintances might improve one's chances.

My Career As An Art Critic

Why was I given the honor of writing the manifesto against the Museum of Modern Art? Because during that period I had a syndicated weekly art column that went to fifteen newspapers. They were all outside of New York, but several were big, including the *Philadelphia Inquirer*, the *Newark Star Ledger*, and the *Long Island Press*. My father had passed this job on to me when he moved to Israel. Of course, I was too young and inexperienced. When I interviewed artists I dreaded the moment when they first met me. Luckily, I knew enough about art to get a conversation going, after which their self-interest usually took over. There were two artists who were definitely not impressed: Salvador Dali and Leonard Baskin.

Dali, who looked like warmed-over death, met me in the cocktail lounge of the St. Regis Hotel. Surrounded by his entourage, he merely reiterated the press release that I'd been sent, a silly puff about a giant chrysalis, butterflies, and jewelry. That was it. He dismissed me.

I traveled to Northampton, Massachusetts, to visit Baskin. A dour man, he kept questioning me. When I told him I went to Music and Art High School, he referred to it as "Mucous and Snot." In his studio there was a large unfinished wood carving of a man with a bird's head and wings.

"Has it ever happened that you carved away more than you intended?"

"No," Baskin said, staring at me with frigid condescension.

Most of my adventures in pursuit of review material were more rewarding. Particularly, I discovered a nascent art movement that became known as "Happenings." I had partied with Red Grooms, Claes Oldenberg, Jim Dine, and Bob Thompson, even at my own studio on East

18th Street. I went along when they staged their theatrical events, and I wrote a column.

I was dating a girl named Sabina, whom I had met while doing outdoor portraits at the Washington Square Arts Festival. We went to her parents' apartment for dinner and I told her stepfather, Dwight McDonald, about the Happenings. He attended the next event and wrote it up for *The New Yorker*. A new art movement was born.

I exhibited with Oldenberg and Grooms in group shows a couple of times, but my work was too traditional and did not fit in.

Then and many times subsequently, I've wanted to be part of an artists' group. I felt the excitement around those artists, but as a Realist I wasn't comfortable with their Expressionism and neo-Dada gestures.

Advice From The Master

There was a relentless shift away from what Soyer and the other beleaguered Realists called "humanist values." This boded ill for the older generation of artists that I admired and for the few of us students who wished to follow in their footsteps.

Bob Cenedella adopted George Grosz' attitudes, while I hoped to have a life not unlike Raphael Soyer's. It was not Soyer's painting style so much that I admired; I thought it was too sentimental. I liked the whole unpretentious left-wing Social Realist culture—precisely what was being destroyed by the Cold War, McCarthyism, and the triumph of Abstract Expressionism.

Cenedella and I couldn't figure out where to go or what to do, with the kind of art we were doing. How could we access the art scene? We were out of art school, painting with all our hearts, getting nowhere. Months, then years went by and finally we decided that we would make an appointment with Raphael Soyer (George Grosz had died.), and ask his advice.

Raphael Soyer had the upper two floors of a small building on downtown 2nd Avenue. I pushed the button by his name, and he came down to open the street door and led us up a couple of flights, past his apartment to his studio.

Soyer invited us to sit in a tiny kitchen area that was partitioned off from the loft workspace. Over the little kitchen table there were many intimate paintings by Soyer's friends and former students. Soyer identified the artists, some of whom, such as David Burliuk and Sol Wilson, I knew.

To our queries, Soyer responded, "Our situation is bad, very bad. To be honest, there is nothing I can do or say that will help you. I can't even find ways to assist the artists of my generation, not even my old

friends, no galleries, no exhibitions. It's as if we're being blacklisted. The Abstract Expressionists and their friends have the art market all sewed up."

I wished that I had a painting up on Soyer's kitchen wall. It seemed that Cenedella and I were in the wrong place at the wrong time.

Soyer showed us his studio, which was quite barren. His painting equipment was by the bank of windows that overlooked the street. Across the expanse of bare floorboards was the sagging single bed, a bare mattress on a metal frame, that appears in so many of his paintings.

We went down to Soyer's apartment, where his wife served us cookies and tea. The living room was crowded with books and cozy furniture, an old-world warmth. A double portrait of Soyer's parents hung over the mantle.

The New School For Social Research

I was one of the four students who received a B.A. degree from the New School in 1960. I didn't know the other three.

Attending a night school in New York was about as far as I could get from life on the Brandeis campus. The teachers, mostly European refugees, lectured from a podium while I sat in the audience and listened. We didn't ask questions. The more students that the professors attracted, the more money they made. Very few students were there for credits, and some would buy a ticket for a single lecture.

Renaissance art history was taught by Paul Zucker, a venerable German follower of the early formalist art historian Heinrich Wölfflin. Zucker was even more pedantic than Hauser had been.

Zucker was pontificating about Titian's Venus of Urbino. This was one of my favorite paintings, a superb reclining nude that I had in mind when I hired Patty Mushinsky.

I called out in the darkened lecture room, "The slide is backwards."

Zucker, irritated at being interrupted, responded haughtily, "It doesn't matter."

Perhaps on some level it wasn't important, but the backwards slide was certainly a good example of Walter Benjamin's thesis that art in the age of mechanical reproduction loses its aura.

At the end of the term, I thought of a clever twist for my final paper. Commonly, ever since Vasari's *Lives of the Artists*, historians taught the Renaissance as a chronological progression of escalating genius. Instead of Giotto leading to Massacio leading to Michelangelo, I imagined that everything went backwards. I started with Il Rosso Fiorentino, who I said influenced Michelangelo, then worked my way backward all the way to Giotto. I argued that each artist eschewed the stylistic excesses of

his predecessor, simplifying and purifying his vision and style.

Professor Zucker gave the paper a B. I looked over the few comments that he had written; they were corrections in the chronology. He never got the joke.

Back then, art history was presented as received wisdom. Now there are revisionist art historians, a wonderful development.

The Boston Museum School

Newspapers were dropping my syndicated art column. After a couple of years, my career as an art critic dwindled away.

My father was willing to support me if I enrolled somewhere for a Master's degree, so I moved back to Massachusetts and signed up at the Boston Museum School. My friend Dick Stroud had already started a year earlier.

The administration put me in the third year, where I went into a studio and painted from models just as I had been doing in Soyer's class the last couple of years.

While I thought that I could paint, and had my own ideas about what I wanted to do, I could see that I wasn't going to make it out there in the cruel art world.

Jason Berger, the third-year painting teacher, was a pie-faced Bostonian with a grating accent. He painted like a French Fauve. The Museum School teachers and students were all enthralled with Matisse.

I had never been interested in Matisse. What could I learn from his paintings? They have no sense of space or structure, none of the painting techniques I was interested in, no perceptions about the tensions of modern life. Escapist decoration was not my thing.

To compensate, I studied Da Vinci's treatise on painting. Leonardo's teachings, I felt, could have been the basis of an art academy, one that would really benefit students, the antithesis of the Boston Museum School. I imagined a pedagogic program that would put together a curriculum of Academic precepts—Cennini, Da Vinci, Vasari, old manuals of drawing, perspective, and anatomy, and finally, nineteenth-century academic precepts.

There was a guest lecturer who, for a change, gave a lecture on

Old Master drawings. In the discussion that followed, I said that it was my ambition to emulate Renaissance artists such as Dürer, Leonardo, and Michelangelo.

"That will never do," he responded. "Very bad influences, you know. They were all homosexual."

Though there was an element of humor in the lecturer's riposte, it reflected the macho, anti-intellectual stance common in the art circles of those days. This was particularly true of those who had been on the GI Bill and of so-called action painters.

The female art students were young, beautiful, rich WASPs. The males were older and from a lower, broader social spectrum. They did not seem to be as bright as the girls.

The other students wore paint-smeared jeans, moving carefully through the dirty studios. But I wore my Brooks Brothers suit, the one my father had bought for me when I started at Brandeis.

The freshman class had over 400 students, mostly those lovely Boston Brahmins. By the third year, enrollment was down to 200. In the fourth year class, there were about 50. In the fifth year, fifteen students were singled out to receive grants to travel abroad. Those who made it through deserved a diploma in sycophancy.

In the fourth year, our maestro was Jan Cox, the head of the painting department. Cox was an aloof, sophisticated Belgian who had a little coterie of preferred students. He didn't seem to be aware that I existed.

In the spring term, Cox approached me, which was very unusual. With a dismissive glance at my little egg tempera painting, he said, "If you are thinking of completing the program, you must paint in oils, and larger, ten times larger. Also think more abstractly."

This was a traumatic moment. I was shocked that he considered me such a bad artist that he would peremptorily throw me out. I would be failing my father's desire that I get a graduate degree. Then again, I had no respect for the school style or Cox's paintings.

I walked. Despite my friend Stroud's advice, I never went back.

I stayed on in Boston for a few years on the fringe of student

life. My father continued to send me two hundred dollars a month. He came from Israel to do a lecture tour once a year and usually would buy a painting.

Boston had a genteel, neglected aspect that appealed to me. There were no new buildings. There was an almost Victorian sense of repression, especially a year or two later, when the Boston Strangler obsessed everyone.

I did a painting of Jan Cox giving a demonstration to his five avid disciples. These were Dick Stroud, David Barbero, Frank Bonipanti, Jack Green, and a girl named Nancy.

If strong emotions, such as hatred and envy, make for good art, then that painting was a masterpiece. I think it might have been.

Jan Cox developed a severe drinking problem and committed suicide. I remained friends with Stroud. Barbero moved to Santa Fe after I did, and became very successful doing semi-abstract landscapes with Matisse-y colors.

I painted my first bar scenes, of Boston nightlife. The downtown area had a red-light district nicknamed "the Combat Zone" because there were so many sailors roiling around. My favorite haunts were Ort's Golden Nugget and The Palace, in whose cavernous space there were three bars, a band, and a dance floor. The crowds were wild, including many blacks. There were also various strip joints, where the women patrons always came in couples and would sit together and dance together until a pair of sailors approached them.

Despite the Museum School rejection, I had found my style: a kind of negative and anachronistic Social Realism.

Boston Friends

There were several of us young artists—Dick Stroud, Johnny Shahn, Richard Lebowitz and me—who wore the same jackets. (This was as close as I ever came to belonging to an artist's group.) Made by Sweet-Orr, the jackets were beige in color and corduroy, the thickest, toughest material imaginable. They had a belt incorporated into the back, like English hunting jackets, and the lapels were absurdly wide. The logo depicted workers in a tug-of-war, unsuccessfully trying to rip the jacket in half. This image was also painted on the wall of the factory, which was in an old loft building in the North End, the "Little Italy" where many of us lived.

The North End was a poor neighborhood, forgotten by time, very European. There were a handful of artists and bohemians, and I felt comfortable there. Stagnating ethnic neighborhoods were essential to my survival as a young artist.

Johnny Shahn had also dropped out of the Museum School and was carving wood and stone. We had been neighbors in Cambridge and were now living a couple of blocks apart in the North End. I still have an eloquent drawing that he did of me at my easel.

Johnny had to leave town for a while, so he asked me if I would take over a little commission he had to draw a pair of sandals for a leather worker who wanted to put out a brochure. This sounded easy enough, but after several attempts I found it beyond my ability. My use of line was too hesitant, too clumsy. I returned the sandals to the sandal maker and regretfully told him that he'd have to wait for Shahn's return.

The famous Shahn line, practiced so eloquently by father and son, and later by Andy Warhol in his drawings of shoes, escaped me. This was not encouraging.

I Have A Dream

Johnny Shahn had a car, so, late in August 1963, we decided to drive down to Washington, D.C. to join a big demonstration for racial integration. On the way, we stopped at the Shahn residence in Roosevelt, New Jersey. Roosevelt was a planned labor community, founded in the 1930s. (One of Johnny's first commissions was to sculpt a big head of F.D.R. for the town square.)

And so it was that I met Ben Shahn, the famous artist who had sponsored me with the supposedly anonymous scholarship to Skowhegan.

While the three of us were sitting in the kitchen having coffee, Ben Shahn startled me. He disapproved of our trip to Washington. He said that the demonstration was pointless.

Nevertheless, Johnny and I drove on and joined the throngs of blacks and whites parading through the streets, holding hands and singing *We Shall Overcome*. By late afternoon we were part of a huge crowd, estimated at 200,000, packed into the Washington Mall. Johnny and I couldn't even see the speakers at the other end of this teeming mass of humanity. There was a hush; Martin Luther King was giving a speech.

I have never heard mention of this, but the fact was that the loudspeakers were defective, giving out a whining echo. We couldn't make out the words. For once the media did a good deed, immortalizing words that the audience never heard.

At that time I was in awe of Ben Shahn. Since then, I have developed mixed feelings about his art. The early 1930s paintings are strong and original, if idiosyncratic. By the war years, Shahn was taking commissions from *Fortune Magazine* and others. He developed a decorative style, and his graphic descriptive line took on a lot of stylistic flourishes that he embellished with calligraphy.

Henry Geldzahler

In Cambridge, Johnny Shahn and I spent a lot of time with Henry Geldzahler, a Harvard graduate student in art history. Henry, who adopted the air of an English aesthete, was Jewish, small, and as round as a butterball.

Occasionally Henry invited Johnny and me to join him for dinner in the posh apartment that he shared with two other mannered students, all of which reminded me of a novel by E.M. Forster. Henry, Johnny, and I would go to art events or hang out in coffee shops. Henry would pick our brains about art.

Geldzahler's later career was a repudiation of all the facts and beliefs that we confided in him.

Henry bought works of art from us. In my case, it was a painting of Cain and Abel—ironically, an image of betrayal.

Within a few years, Geldzahler became the Diaghilev of pop art. He became assistant curator of American art at the Metropolitan Museum under the more conservative Robert Beverly Hale. Replacing Hale, he put together a blockbuster exhibition of contemporary American art. Starting with Abstract Expressionism, the show included pop art, op art, and minimalism. At the opening-night invitational party, Andy Warhol stood at the top of the grand staircase and introduced himself to everybody as "Geldzahler's wife."

To me, and hopefully to a lot of other people in the art world, Geldzahler's exhibition was a travesty of everything I liked about the Metropolitan Museum.

Dick Stroud

In 1959, while I was studying painting with Raphael Soyer at the New School, I met Dick Stroud, a handsome black art student who had gone to Music and Art five years before I had. Dick's teacher was Prestopino, an artist whose work looked a little like Ben Shahn's, and who had also done commissions for *Fortune Magazine*.

Stroud and I got to talking as we were coming down in the elevator from the ninth floor, where the art studios were. I invited him to a party at my loft.

"Thanks," he said, "but perhaps I should warn you that I don't play the bongos. I have no sense of rhythm."

Stroud was as enthusiastic as I was about becoming an artist, though he was more intuitive and I was more pragmatic. He participated in the lively conversations with Prestopino in the school cafeteria that continued long after the model had resumed posing.

After I got to know Dick, he invited me to his large, gloomy slum apartment where I met his wife, Connie, and their baby daughter, Lisa.

He showed me a series of five little drawings that he had made of his wife, each in a little frame: head, breasts, pubis, knees, and feet. Stroud had a light, understated touch, a bit like Manet. He had softened Connie's New England gauntness.

About that time, Stroud asked me to go with him to a barbershop. Apparently, white barbers often turned away black customers, saying that their hair was too difficult to cut. I sat watching, and he got a good haircut.

Another example of my racial naiveté: In the summer, Dick pointed out that he was getting a suntan, while up until then I had just assumed that blacks were black.

In Stroud's art class, he had a flirtation going with a small, delicate deaf girl. He brought me along to visit her at her parents' elegant Fifth Avenue apartment. My role was to reassure the doorman and the parents.

Dick Stroud was an intrepid lover. His love life could be all-consuming, with several relationships going at once. Yet it seemed that there were mostly warm and positive feelings. The girlfriends were almost always from very wealthy families. In their formative years, they were eager to enjoy the novelty and excitement of bohemia. Stroud was a solicitous guide who preferred giving to taking. He wanted only love, not caring about material considerations.

Dick was a fascinating talker, enthusiastic about people and art. He kept faith over the years that things would come his way. At the last minute there would be a sale of a painting, another teaching job, a new studio space, an invitation to somebody's summer home. While he lived on the margin, Dick nevertheless made an effort to do things for people, even the most spoiled people. Eventually they would be absorbed back into their privileged society, leaving Stroud perforce true to his bohemian lifestyle.

Over time, Dick accrued responsibilities: wives, mistresses, children, multiple jobs. He and I are still good friends, and I have observed that he takes all of his new responsibilities on as best he can without letting himself be circumscribed.

There has been much continuity in Dick Stroud's art. The style remains figurative, spontaneous, sketchy. Stroud's countless drawings fill drawers, folders, portfolios. There are stacks on workbenches, shelves, and under the bed. They depict mostly nude women, but also portraits, animals, and a few landscapes.

Seen in the warmth of his studio, accompanied by good conversation, these effervescent jottings come to life. Their reticence registers as an endearing purity, removed from the strident exhibitionism of the art world.

The second summer that I went to the Cummington School of the Arts, in 1960, I arranged for Dick Stroud to come too. Cummington

was just a few miles from Hingham, where Dick's wife, Connie, grew up. In the fall, Dick decided to go to the Boston Museum School. I went back to New York to finish at the New School and followed Dick to Boston a year later.

Besides my painting of Jan Cox's sycophants, which included Stroud, I did another painting of him as the pistil in the center of a big flower, the surrounding petals being various girls.

While we were at the Museum School, in the evenings Dick and I often visited the cozy Cambridge apartment of sisters Stephanie and Ada. Their guests were an intimate group of young artists. The sisters treated us to good dinners, marijuana, occasional hallucinogens, and group sex.

Stephanie was a perfectly beautiful redhead, while Ada was a bit ungainly. It was understood that they were to be treated with equal attention.

I usually left after dinner, when drug taking prevailed. But one evening my friends talked me into smoking some surprisingly strong marijuana. Stephanie's room seemed to be a sanctuary, her bed an altar. There were candles burning all around, and as she hovered over me she seemed to metamorphose: one moment a saint, the next a pig.

Stephanie and I both lived in Cambridge, so some mornings we would walk to the Museum School together. It was a long trek down Massachusetts Avenue and across a bridge spanning the Charles River.

A few weeks later, Stroud went around to the various studios at the Museum School looking for Stephanie's friends, asking us to meet with him in the painting studio at the end of the day. Five or six of us gathered, and Stroud informed us that in the future Stephanie and he would be an exclusive couple.

Not long after, Stephanie disappeared from our scene altogether.

Forty years later, Dick Stroud showed me a photo of a pretty black woman. This was Stephanie's daughter, Cheryl, whom she had put up for adoption at birth. He had never heard from Stephanie, but his daughter had just gotten in touch with him.

In Boston there were wild parties where young painters got drunk and violent. More than once I found myself in fights with these

wannabe Jackson Pollocks. Dick came to my defense. Just the sight of his clenched, twitching jaw made them back off.

Though Stroud was a faithful friend, I could not always say the same for myself. Sometimes jealousy got the better of me. At Cummington he was courting a young, frizzy-haired Jewish girl with a big bosom. She was very sincere and enthusiastic. One afternoon I drove a bunch of students a few miles down the road to a swimming hole. Dick and the girl, wearing only swimsuits, wandered off. As evening approached, the rest of us looked around and called their names, but to no avail. I drove the others back, just in time for dinner. I knew I should drive back to look for them—a black guy with a white girl, wandering around half-naked, was a scary prospect. But I didn't go. They finally showed up, having surprisingly managed to hitch a ride. Stroud looked shaken, but he didn't say anything.

I've written about the time that I took his girlfriend Susan to Washington. When we returned to Boston she stayed with me. Dick showed up at my place and asked her to come back to him. I protested and he backed off. Susan and I didn't last long as a couple, though we remained friends for years, both living in Santa Fe. By then she had two children. She became increasingly unstable and reclusive over the years.

Museums In Boston

Not long ago I visited Dick Stroud, still living in Boston, and we paid a visit to the Boston Museum of Fine Arts. Upwards of thirty-five years had gone by since we had been students.

Back then, we approached the elegant Classical façade by walking under the high-pedestalled bronze statue of the Indian on horseback and up the path between the two stone lions. Now we crossed a parking lot at the side of the building and entered a hangar-like addition designed by I.M. Pei. Just inside, there was a huge waste of space featuring a gift shop and a cafeteria. This was more or less where that unpretentious little restaurant had once been.

Disoriented, I followed Stroud as we came into the collections backwards, corridors running every which way. In the good old days, we would have been confronted by the majestic staircase over which arched the Sargent murals. At the top was the Grand Salon with its high ceilings and enormous Baroque tapestries. Deeper in the bowels of the museum was a rotunda hung with dozens of cabinet-sized mid-nineteenth-century paintings: Monticelli, Boudin, Jongkind, Diaz. Mid-afternoons, in an adjacent room, there were elderly ladies serving tea and little pastries or fresh-baked cookies.

Coming in from the back as we were, the rotunda was the first visible landmark. It was now hung with leaden early American portraits.

As students at the Museum School, Stroud and I had been given the assignment to copy paintings in the Museum. Dick chose an El Greco that depicted a monk whose black vestments had a big white cross on the chest, one of the prides of the collection. I set up in a little side room, using egg tempera and even gold leaf to copy an anonymous medieval panel of Saint Michael trampling on the devil.

During the weeks that I labored on that little painting, no more than three people ventured into that room. One happened to be the museum director, Perry Rathbone. He walked imperiously by, without a glance. Years later, Rathbone was caught smuggling a painting from Europe to the United States and lost his job.

The Isabella Stuart Gardner Museum was just on the other side of the Museum School. When I was depressed, I used to wander over there, into the gorgeous interior court with its hothouse flowers. I would immerse myself in the heady atmosphere of Jamesian high culture. The Gardner was usually empty except for the ancient guards, who I fantasized had once been Isabella's servants.

I had some favorite paintings, such as Sargent's giant flamenco scene and Titian's *Rape of Europa*. The Gardner wasn't a place to study artworks systematically. Paintings were hung in the dark, often high up near the ceiling or obscured by furniture. Many were without any identification. Nothing was allowed to ever be moved.

The Gardner's ambiance was later violated by thieves who left the old guards tied up in the guard room and then removed a load of art, including Vermeers, Rembrandts, and, puzzlingly, minor etchings of buxom bathers by Andreas Zorn.

Like the Gardner, the Fogg Museum on the Harvard Campus had a snobby aura of exquisite taste. On our trip down memory lane, Stroud and I revisited the Fogg and enjoyed it immensely, feeling as proud as if we were Harvard alumni. Coming out of the building, we turned right. Along the sidewalk there were some shrubs. I had a vivid flashback. About forty years earlier, at night, I had walked along that same stretch of sidewalk. Drunk and horny, I wandered back behind those very bushes, lay down, and masturbated.

As a young artist I had been quite turbulent. Now I only felt alien.

Starting My Art Career

After leaving the Museum School, I moved to the North End of Boston, living in a coldwater flat on Copp's Hill Terrace. I had a panoramic view with a graveyard below my windows and the Boston Harbor beyond.

My only source of heat was a pot-bellied stove. There was an Italian outdoor market a few blocks away, from which I scrounged wooden crates and broke them up into firewood. When the winter cold intensified, I had half a ton of coal delivered, which I then hauled from the basement coal bin in a bucket up to the third floor.

I made it through the winter. Then my father, always a Zionist, prevailed upon me to come to Israel. I tried to adjust to the promised land for six months. My stepmother, who hadn't been told that I was coming, wasn't happy that I was there. So much for Zionism. I returned to Boston's North End.

I found a place in an innocuous slum tenement owned by a stolid Polish woman. She told quite a story: arriving in this country, she scrubbed floors for ten years, saving money. Unfortunately, she had a mental breakdown and went to an asylum. Recovering, she scrubbed floors for ten more years, finally buying this building.

I could have the top floor front apartment for only fifty dollars a month. There was a catch. An old alcoholic couple was already living up there and had been for years.

The Polish landlady introduced me to the old couple, who looked like clowns with their big red noses. They weren't exactly pleased to make my acquaintance.

Frusto the Magician and his wife lived in the back, using the front rooms for storage. They consumed cheap wine by the half-gallon,

and for years had been leaving the empty bottles and the cardboard boxes in the rooms that I was to clear and occupy.

During the week that it took to carry the debris down the five flights, I visited with the Frustos at least once a day, joining them for a drink or two. In the garbage, I came across some of the magician's old equipment—for instance, bouquets made of colored feathers attached to delicate folding metal rods. There was also a large wire mesh tumbler that Frusto concocted to spin dry the feathers after he dyed them.

On my visits to their apartment I'd bring the various contraptions to find out what they were and if Frusto wanted to keep them.

I doubted that either of them ever left those terribly stuffy rooms. I couldn't imagine them climbing the stairs. Perhaps they had their food and wine delivered.

Once I was moved in, I did a crazy painting inspired by the landlady. It depicted a long institutional hallway going back into space with naked men on one side and naked women on the other. A dim twilight was visible through small barred windows. I called it *The Sun Also Sets, or The Polish Insane Asylum*.

In developing my painting style, I tried to focus on things that disturbed me, combining Social Realism with sexual fantasy.

Breakdown

By 1964 I was feeling shaky. Having been ejected from the academic world, then failing to find my place in the Zionist world, I felt alienated in Boston. My personal life was unsettling, too.

Late in the winter, a terrible rash began to develop on my face and private parts. It seemed to be poison ivy, which I had had before so severely that I'd been hospitalized. But how could it be? There was snow everywhere.

I went out and bought several bottles of whiskey and some food, then holed up for the next ten days. At its worst, my eyes were swollen closed and I had to clear a passage in my nostril with my penknife. Finally, the rash ran its course.

When I emerged from my apartment, people didn't recognize me. I had lost weight and my face remained swollen for weeks. Somebody said that I looked like Broderick Crawford.

I found a job refurbishing and painting the exterior of an Edwardian house in Cambridge and managed to save seven hundred dollars.

In early spring I set up the box of my narrow French easel with the dry pigments, sable brushes, and little palette that I needed to paint egg temperas, packed my suitcase, rolled up my sleeping bag, and took off, hitchhiking westward.

I hoped to start a new life and do art totally independently of the art world I had known.

A New Start

I hitched into Cincinnati with its four beautiful bridges spanning the Ohio. There had been a tremendous flood; the water was still receding. First Street, with warehouses and docks, was clogged with mud and debris. Second Street, warehouses interspersed with residential buildings, had water damage six to eight feet up the walls.

I found a second-floor apartment in one of these waterlogged buildings. The landlord, a Jew who lived in the suburbs, rented it to me for $30 a month. My windows looked out over the Ohio, where three bridges were visible. One was very close. I painted the workers repairing it.

Scavenging along the riverbanks and in abandoned buildings, I found rudimentary furnishings. In the reeds, I found a crate of nine jars of Smucker's Jam, all different flavors.

My landlord, who had a laundry business, gave me a stack of shirt cardboards to paint on. I gessoed them and developed a routine of doing a painting a day: scenes along the river, derelict buildings, and portraits of the kids who followed me around.

I painted a spastic boy who lived next door. He spent hours banging on a partially broken typewriter, producing indecipherable messages. I gave him the portrait, as I did with the other neighborhood boys.

I was reading Dostoevsky's *The Idiot*, which had a strong influence on me. I was a bit crazy.

This sojourn by the Ohio River lasted less than two months, though it seemed longer. I bought a very small motorcycle, 50 CCs, for two hundred dollars. Behind the seat was a rack onto which I strapped

my suitcase, French easel, and sleeping bag. I had about twenty-five paintings, and they fit into a manila envelope.

This little cache of work was done totally on my own, and I had a good feeling about it. They have all disappeared over the years.

Wandering

My new bike wouldn't go over 40 miles an hour, so I stayed on the back roads, stopping often to paint. At night I slept by the bike or in abandoned buildings. I saw lovely country in the Ozarks.

Eventually, I found myself in New Mexico. A sign by the side of the road said that the D.H. Lawrence Ranch was just ahead, and further on was Taos, an artist colony. I took the detour to the Lawrence Shrine, a little open chapel. His ashes had been mixed right into the cement of the memorial. Over it, there was a naïve painting of a tiny man with his arms outstretched toward a vast valley surrounded by mountains, much like the actual view beyond the chapel.

Taos

Coming into Taos in the evening, I slept in Kit Carson Park on the edge of the town. The next night I found an abandoned adobe in a neglected-looking area that was a block behind the plaza. A dirt alley, Ledoux Street, meandered downhill from this building.

In the morning I was awakened by the owner of the building, John Norton. He was about to start remodeling the house, turning it into a gallery that he was going to name The Seven Blue Doors. We got to talking, and he hired me to help with the construction work.

Norton was a steel worker from Pueblo, Colorado. His face was all red from working at the furnaces. He had a wife who was a nurse and a bunch of children. Some years later, he ended up in Santa Fe working for Gerald Peters, our great art mogul.

Wandering down Ledoux Street, exploring a bit, I found an empty mud hut at the back of a lot. I inquired at a nearby house, and

surprisingly, a little old lady gave me permission to stay there. She had written a book about Kit Carson, so I guess I wasn't too wild for her. This tiny adobe turned out to have once been an outhouse, but so long ago that there was no smell. I found a large piece of plywood to lay across the holes. Having become used to sleeping on the ground, I didn't need a bed.

Again I painted small egg temperas, landscapes of the surrounding neighborhood and portraits of the local kids.

Further up Ledoux Street was a boarded up adobe garage with old swinging wooden doors. Again, the owner gave me permission to clean it up. I hauled away a lot of debris, which I threw in a kind of dump behind my little adobe. When I got down to the hard mud floor, I found a mummified cat. I painted on a long board: "Dead Cat Gallery." Weekends I'd open the wide doors, hang the sign out, and wait for someone to wander up Ledoux Street.

Every evening, an old man wearing brown and white shoes would stroll by and nod to me, but never look in my gallery. This was Emil Bisttram, whose studio was at the bottom of Ledoux Street. He had done murals in the 1930s. There was one in the Taos courthouse. Then he switched to a Kandinsky-like style and was influential in a group called the Transcendentalists. They were very unusual in this land of Western art. I was too shy to ask Bisttram to look at my paintings, or to visit his studio.

If only I had communicated my admiration to Bisttram, as I also failed to do a year later in New York to Isabelle Bishop when I had a studio next to hers. They most likely would have been happily surprised that there was a young artist so interested in their careers.

Across the alley from the Dead Cat were some rundown apartments. I visited one of the tenants and saw that on his walls were several excellent paintings, rail yard landscapes. He said they came with the apartment furnishings. The artist was Blumenschein, arguably the best of the Taos Society of Painters. Known for his Indian subjects, these had been done at the end of his life, when he had moved from Ledoux Street to Albuquerque for health reasons. That group of adobes has been

made into a museum, the Blumenschein Compound. One of those rail yard paintings is still hanging on the wall.

The Dead Cat Gallery, however, has not been rediscovered.

Next to Bisttram's studio on Ledoux Street was, and is, the Harwood Foundation. It was a cluster of large, crooked adobe buildings that housed a library full of French books. On top of the sagging bookcases were numerous woodcarvings by Patricio Barela, a primitive drunk local visionary who was sponsored by the WPA. There was a good collection of *retablos, bultos,* and religious artifacts. They were hung, along with a few excellent Taos Founder paintings, in the gloomy spaces between the bookshelves and in the hallways.

The Harwood Foundation included an upstairs studio, approached from outside by a crooked wooden staircase, like in a Western movie. This studio was being used by a tall, handsome young artist dressed like a cowboy: Ned Jacobs. He painted Indians. He said he had lived with a tribe that had accepted him as a brother in a blood ritual.

I had seen a painting of Jacobs'—four Indians on horseback—in the lobby of the La Posada Hotel, in a place of honor along with a great many other paintings by Taos artists in the high-ceilinged lobby. The clerk told me that Eisenhower had almost bought it.

Also in the La Posada lobby there was a door beside the check-in desk that opened into the office of the Greek owner. The walls were covered with obscene paintings done by D.H. Lawrence in the last years of his life. I paid five dollars to see these twelve paintings—highly neurotic images, painfully amateurish in execution.

Across the plaza from the La Posada Hotel was La Cocina, a Mexican restaurant. Behind the dining area there was a lounge. Over the bar was a mural, caricature-style, that depicted a spirited revelry of local characters. Among them I recognized Antonio Mendoza, a round-faced guitarist who was often actually there, playing *Malagueña* and other Spanish favorites.

Many a night I sat in that dark lounge wondering if the convivial bohemians of the mural would make an appearance. Perhaps they were already there in the room with me, but not quite up to form.

Here I was in the art colony, but I never found the artistic camaraderie.

Santa Fe

I'd heard that there was another art colony in Santa Fe, an hour and a half south. I packed my few belongings onto my little bike, leaving a few larger paintings that were done on plywood in the adobe shack, and moved on.

My spirits lifted when I drove into Santa Fe and saw the lovely plaza, with its obelisk, gazebo, and bronze bell that children rang for amusement. I asked someone where the artists lived and was directed to Canyon Road.

Driving slowly up this dirt street, I marveled at the little adobe houses with paintings in their windows and simple signs announcing studios and shops. I visited two of these studios that were across the street from each other.

The one on the left belonged to Hal West, and in his window was a painting of a hitchhiker on a desolate road. It looked like Depression-era art, and I almost felt I could have done it. Hal was friendly, a desiccated old coot with a wry smile. He offered me some very black coffee from a stained pot that was sitting on an old wood stove.

On the right side of the street I met Jim Morris, another laconic old-timer. Resigned and sedentary, he seemed slightly dazed. The front room was full of his paintings, all depicting agitated little puppet-like people in Expressionistic Southwest surroundings. I removed a small one from the wall and held it up in the light of the doorway. Rehanging it, I noticed that the paint on the wall around it had faded.

Both West and Morris were good artists, my kind of artists. Their simplicity, perseverance, and futility appealed strongly to me. I could fit in here. My brother Gabriel points out that this sentiment could be my credo.

I always wanted to do art that had the simplicity of directness and sincerity. Perseverance meant keeping faith in my early inspiration

and long-term vocation. The extreme of perseverance is to accept futility and, perhaps, even find humor in its absurdity.

Santa Fe was a sleepy Spanish-American village that seemed to live in the past. It had had an art colony since the First World War. The locals and old artists were welcoming. In the 1970s a new generation of artists came to town. I have related the story of my happy times in the Santa Fe art community in my previous book, *Santa Fe Bohemia; The Art Colony 1964-1980*.

New York Again

After about a year in the enchanted land of dirt streets and mud huts, I got to thinking that I should try again to make it in the real art world, so I went back to New York. I found a studio just a block from where I'd lived before, and from the same leasing agency. This was on the top floor of a narrow old building on Broadway and 17th Street, just off Union Square.

The space I rented, for two hundred dollars a month, was a stark room with big windows and skylights. The location had special significance for me. There was a group in the 1930s called the Union Square School: a handful of artists taught by Kenneth Hayes Miller, who incorporated Renaissance techniques into their depictions of bums, shop girls, and union agitation. These artists included Reginald Marsh, Edward Laning, Isabel Bishop, and Raphael Soyer.

Down the hallway was Bishop's studio, but I was too shy to introduce myself to her. Once, in the rickety elevator going up to my studio, there was a young lady. It was uncanny how much she looked like one of the women in Isabel Bishop's paintings from the 1930s. "By any chance," I asked, "are you on your way to pose for Mrs. Bishop?"

"Why yes," she said demurely, then added, "My mother used to pose for her too. I'm wearing the same clothes she wore."

I holed up in that barren studio and painted. The only image that comes to mind now is a depiction of an old porcelain sink that hung crookedly in the corner.

I had a party and invited old friends, but hardly anyone came. After a couple of months my money ran out. I had to give up that great space. I found a job as a janitor in a slum tenement on Second Avenue between 95th and 96th Streets, the edge of Harlem. It included a free apartment and it paid fifty dollars a month. I still feel a sense of failure when I think about how I had to retreat from the artistic environment of my studio on Union Square.

Uptown, the winter months were hard. I got up before sunrise to stoke the coal furnace in the low-ceilinged basement—dark, cold, dank, and rat-infested. I shoveled the ashes into garbage cans and hauled them up to street-level through metal shutters set into the pavement. Now I knew why garbage cans were called ash cans, and I understood better the Ashcan School, an art movement that included Robert Henri and John Sloan.

There were other tasks. I mopped the six flights of stairs once a week, I threatened tenants who were behind in their rent with eviction, and I showed empty apartments, but was instructed to tell blacks that the landlord wouldn't accept them. I added that they had legal rights, but they just stared at me apathetically.

I did some strong paintings. One was of a tenant whom I had evicted. His apartment had been crammed with broken appliances, mostly radios and televisions. I portrayed him sitting way in the back looking defeated, surrounded by all this stuff that, remarkably, I remembered and depicted plausibly. Another painting from that year illustrated a subway packed with ugly people.

I had a wonderful girlfriend at the time, Maritza Arrastia, half Cuban and half Puerto Rican. She lived in the projects with her minister father, her mother and brother, up Second Avenue on 106th Street.

I would walk the ten blocks up Second Avenue to pick her up. Once I noticed that a cop car was cruising slowly behind me. Pulling alongside, the policeman beckoned. "Where are you going?" he asked.

I told him.

"Be careful. These are the worst ten blocks in New York."

Back To Academia, 1965-1966

Maritza was enrolled to start at Wisconsin University in the fall. I bought an old Volkswagen, and we left New York. My cousin Judy, pretending to be a fellow student, picked Maritza up at her parents' house so that they wouldn't realize I was going out with her.

In Madison I thought I might as well inquire about the M.A. program. By a stroke of luck, an art professor happened to be in the office and overheard my last-minute inquiry. This was Robert Grilley, the oldest art teacher and only Realist left in the department. He had been a student of John Stuart Curry, when Curry was artist-in-residence of the agricultural school.

Grilley whisked me through the application formalities and arranged for me to have a private studio in an old rambling Victorian house that was used by the faculty for offices and work spaces. I had a little room in the attic whose upper walls slanted like a garret in Paris.

Under the watchful eye of Robert Grilley, I painted still lifes and Social subjects all that winter, never getting to know the thirty other art professors or their coteries of students, never concerning myself with their embattled crosscurrents of Modern Art.

Now that I was back in graduate school, my father reinstated the two-hundred-dollars-a-month allowance.

Grilley was fond of pointing out to his students that their palettes, so caked and crusted, displayed richer and subtler paint quality than their paintings. This wasn't true in my case, because, using oil at his request, I kept the palette clean except for little dabs of color arranged systematically along the two outer edges.

Grilley encouraged a varied, studied use of the pigment. He showed me how to twirl a sable brush so that the pigment dragged and

built up. This brought back memories of Music and Art. Again I was trying to paint apples "good enough to eat."

Robert Grilley also conducted a graduate seminar in which about a dozen of us discussed art. At the first meeting he ran some slides by us to see what we knew. They were examples of traditional Western paintings, most of which I recognized. Not so the other students. After I'd identified a couple of them, I tried to hold my tongue. But no one else spoke up. Perhaps they would have done better with contemporary art. Towards the end of the dispirited session, Grilley projected a drawing of a cottage with a bicycle leaning in the doorway, all carefully rendered. There was a long pause.

"Rembrandt?" a shy girl ventured. No. I had a flash of clairvoyance. "Adolf Hitler?" Yes!

After that, I could do no wrong in Grilley's estimation. I graduated with a four-point average.

I have always had visual sensitivity and good memory when it comes to works of art. These powers of observation have not extended to the world around me. I seldom remember the color of people's eyes or hair, whether the men had moustaches or beards, what people were wearing, and so forth. Because of this, the subject paintings that I do are more generic than I might wish.

Nearing the end of the school year, Grilley took our seminar on a road trip to Chicago, more than three hours each way. We visited the Chicago Art Institute, one of America's major museums, where Grilley wanted to show us a major painting by Balthus, his favorite contemporary artist. We searched the galleries, but it wasn't hanging. This was another instance of the disappearing Realism that was so prevalent in museum collections of Modern Art.

I was required to put together a thesis exhibition of the work I'd done during the winter. Grilley insisted, to my chagrin, that I make my own frames. He had elaborate ideas about frame construction. I was to use common lumber: 2x4s, 1x6s, 1x2s, and quarter rounds. I nailed and glued, mitered, nailed, and glued some more, then painted several coats of acrylic, steel wooled, sanded, and finally beat the frames with a chain

and stabbed them with an ice pick. Those were some heavy frames.

My little exhibit was comprised of twenty-four paintings, and I thought they looked good. Over the years they have all, along with their clunky frames, disappeared.

Grilley asked me to return in the fall to do another year and get an M.F.A. I could be an assistant drawing teacher. I was feeling that there was something intrinsically false about college art departments, that they fostered complacency and mediocrity. I was anxious to get back to Santa Fe, thinking I'd rather live like the artists on Canyon Road than Grilley. I declined the offer.

A couple of years later, I visited Madison and dropped in at Grilley's office. He didn't repeat his offer. In fact, he acted as if he hardly knew me.

Etching

When I was a student in Madison, besides my ideal situation with Grilley, I discovered that there was a teaching grant available in the etching department. I applied and got the position, despite the fact that I'd only done four under-etched plates five years previously at the Boston Museum School. Maybe no one else applied; the job was basically janitorial work—heavy maintenance.

The intaglio professor was Clair Van Vliet, an unmarried redhead in her late thirties. Clair was intelligent, highly motivated, authoritarian, and neurotic. She was there for a year, standing in for a professor on sabbatical. He had a funny name: Dean Meager. Meager was famous locally for the innumerable silkscreen prints he'd done for hotels and motels. I wondered how this producer of kitsch could be the head of a university art department. Clair had more exacting standards.

My work in the etching department required that I get up very early, bicycling to campus in the dark. During the winter, it was so cold that I could hardly breathe.

Our workshop was in the basement of a big institutional building

just like the buildings on either side and the buildings across the lawn. This large, laboratory-like space featured a good deal of expensive equipment. We had a walk-in closet that was knee-deep in copper plates, big and small, new and used.

My tasks were to scrub down the long tables and institutional sinks, to check on the acid baths that were in a ventilated glass enclosure, adjusting the mixture of nitric acid and water, and to mix a daily portion of ink, grinding black pigment and plate oil with a glass muller on a marble slab. I also gave basic instruction to beginners and answered whatever questions I could.

I studied several how-to etching manuals and tried the traditional methods. My favorite turned out to be the oldest: engraving. Clair Van Vliet, on the other hand, wanted to expand the boundaries of the medium.

The graduate students specializing in graphics, who had been there before us, liked viscosity printing, a method that allowed for color and happy accidents. They used big gelatin rollers that were easily damaged and cost hundreds of dollars. They favored shaped plates and embossing, practices that I thought hokey. They also made marks on the copper with motorized tools, producing a sound like having one's teeth drilled.

Van Vliet pushed the Masters students into doing their thesis prints with contemporary duplication equipment: mimeograph, Xerox, photo-engraving, and whatever. She brought in a bunch of expensive office equipment. If any of them are still doing art, it is probably computer-generated.

Clair was high-strung and had a short fuse (to mix metaphors). Ours was a love-hate working relationship. The tension sometimes reached near hysteria.

Once when we were trying to move a tray of nitric acid that was about four feet wide, Clair stumbled and the acid flew all over me. She hosed me down while we laughed uncontrollably. I had to take off my clothes and hang them over the radiators to dry while I wore a smock and my winter coat.

At the end of the school year, Maritza and I invited Clair to

dinner at our dilapidated student apartment. We proudly played our latest James Brown record. Clair hated it.

In the 1970s, Clair Van Vliet came to Santa Fe, as she was being honored at the Palace of the Governors with an exhibition of her limited-edition books. I went to the opening, and the next day she came up Canyon Road and paid a visit to Laughing Boy Gallery, my twenty-dollars-a-month studio. I showed her some etchings that I had done. I could see she was not impressed. Since then, I've done about two hundred plates, while running the Santa Fe Etching Club since 1981, which has had dozens of members.

In the 1990s, Clair Van Vliet came to Santa Fe again to give another lecture about her New England Press, which has published a number of award-winning limited-edition books.

I could hardly accept that this was the firebrand boss I'd had; she was now old and bloated. On a display table in the lobby were her publications. I was looking through one when the lecture started, so I took it to my seat. Not long after she started talking, a museum official interrupted her to announce that one of her books was missing. I sheepishly raised it, and they retrieved it. Even so, she didn't recognize me. I left before the reception.

When Clair had visited my studio on her first visit, I was mortified by how unimpressive my work looked, imagining that I was seeing it through her eyes. This time her work looked unimpressive seen through my eyes.

Robert Beverly Hale

In the 1980s I made several trips to New York to study drawing at the Art Students League. Perhaps it was a middle-age crisis. I wanted to re-think and improve my artwork. For a couple of months during the winter, I would draw eight hours a day, five days a week.

Two of my high school friends, Bob Cenedella and Charles Haseloff, had large lofts in Soho, where I stayed. I hoped to soak up some New York culture.

Surprisingly, Robert Beverly Hale's legendary anatomy class was still going on, though he was in his eighties. I signed up and studied with Hale two consecutive winters.

Hale was totally deaf and a little dotty. His lectures probably hadn't changed much in the last fifty years, but there were lapses, repeats, and skippings. The content was still quite sound and his demonstration drawings were elegant, done with a long, charcoal-tipped wand on a high white board.

These anatomy lectures took place at the far end of the long, gloomy studio where we drew from either of two models who posed on platforms surrounded by dozens of folding chairs occupied by dour, silent students. Windows banked the north side of the cavernous room, so dirty that we could barely see through them. There were tall buildings close by; not much of the winter light filtered in. Pigeons that we couldn't see cooed incessantly.

The room had 40 hanging lights whose shades were like those in pool halls. Robert Beverly Hale enjoyed pointing out what havoc these lights played with the shadows on the models. He highly recommended that we make up our own shading as if there was only one light source, a concept easier said than done.

This theory of the single light source is extremely important to the traditional artist. I went to the Metropolitan Museum and discovered that almost every painting done between 1400 and 1850 followed this precept.

The Hale students drew on big floppy pads of cheap newsprint paper, using charcoal or Conte crayon. The first smudged; the second couldn't be erased. Their drawings featured bulbous generic forms, often striated with "internal contours" as if the models had been wrapped in ribbons or sliced into sections. Their methods were repugnant to me. I continued to draw what I saw in a literal manner in a small, hardbound sketchbook, using a pencil and an eraser.

Hale never critiqued our drawings while we drew the model. He would sit at the opposite end of the room where he lectured, and students would bring their sketchbooks to him. He would flip through

them, correcting the anatomy and other mistakes. I couldn't understand how he could do this without looking at the models. I never showed him my work.

Hale's lectures and lessons were faded reprises of the Academic theories of past centuries: once coherent concepts that had been all but forgotten. The key was this: One should draw what one knows (assuming extensive study), not what one sees.

It took a long time for Hale's ideas to penetrate my obstinacy. Studying the Old Masters, I began to understand the importance of chiaroscuro: the rounding of forms, cast shadows, reflected light. I began to see that the Masters could make up figures without using models, relying on their understanding of anatomy and structure. I immersed myself in the study of traditional art and art theory, hoping to divest myself of any lingering Modern Art notions.

Ironically, Robert Beverly Hale did not use academic ideas in his own art, which he never seems to have exhibited. From what I could gather, he did drip and splash abstractions. Then, too, I doubt if the thousands of students who passed through his classes were seriously interested in trying to paint like the Old Masters.

Back when Hale had been the curator of American art at the Metropolitan Museum, his purchases for the collection spanned a spectrum of styles, from Thomas Hart Benton to Jackson Pollock. After Hale's death, as a tribute, there was an exhibition of his acquisitions. Inappropriately, it was held at the Philadelphia Museum instead of the Metropolitan. Perhaps this was because of the ascendancy of his former assistant, Geldzahler, to his position. I never talked to Hale about Geldzahler, partly because Hale was deaf, and also because he was too much of an old-fashioned gentleman to say anything disparaging.

Gary Faigin

Gary Faigin was perhaps the last artist whose friendship had an influence on me. We met in the late 1980s when I was rethinking my ideas about art.

It was my third winter in New York. I signed up for Robert Beverly Hale's class, but Hale didn't show up. Instead, a cocky young man strode into the big dingy studio: Gary Faigin. What a disappointment that was. However, I stayed on and had to admit that Faigin knew a lot of Hale's routine.

In Santa Fe a couple of years later, I noticed in the paper that Gary Faigin was coming to town to teach a drawing workshop. I told my drawing group that he was a good teacher, in effect rounding up students for his class, though he didn't know that I existed. There was a hitch in his arrangements, so he ended up teaching the drawing class in my studio.

Gary began setting up summer workshops in Santa Fe, and in a few years these burgeoned into the Academy of Realistic Art.

Gary and I often painted together, and we both showed our work at Frank Croft's gallery on Canyon Road. Gary and I went out painting landscapes together, and we shared the expenses for models and did nudes. We even painted nudes of Gary's beautiful wife, Pam.

Faigin taught a class in perspective that I took and found rewarding. Speaking of perspective, Gary did a painting of my red truck in the driveway. He was crammed between the front of the truck and the wall of the house. Despite his expertise, it came out elongated, but was a hell of a painting anyway. I still have it.

I assisted him in teaching some classes, and sat in on others. On one occasion, we both reverted to being students, along with some of the best local Realist painters. This was for a workshop taught by Martha Mayer Earlbacher on Caravaggio-like underpainting techniques. I found the technique somewhat turgid, but Faigin took to it. His work changed profoundly.

Goodbye to the Academy of Realist Art

Gary Faigin's wife, Pamela, abandoned her career as an architect to take over the administration of the Academy. The school kept expanding, bringing in more artists to teach workshops. Classes were held in auxiliary buildings at the Carmelite monastery at the top of Camino del Monte Sol, near my house. The main building of the monastery had once been a well-known tuberculosis clinic. Now there were so few nuns that rooms were available for the visiting students.

Eventually, someone told the Catholics that the art classes were using nude models.

Gary and Pam were thinking of moving to Santa Fe. They had just had a child, and they were ready to move out of New York. Try as they might, they could not find an art school space comparable to the monastery. Pam had a twin sister in Seattle, so they moved the whole operation to the west coast. That was the end of the golden days for the Santa Fe community of Realist painters.

Even after the Faigins moved to Seattle, I worked with Gary conducting museum tours in New York and Paris. The two of us would reconnoiter in the museums a couple of days before the students arrived, picking the paintings we would discuss over the next week. I'd tell Gary all the art history I knew. Then we took our flock of ladies around, Gary condensing, clarifying, and enthusing over what we'd discussed. I would embroider around the edges.

Listening to Faigin, I realized that one of my problems as a teacher was my lack of communication skills. I understood the art, but not the students. Gary would pick up all their names and little quirks from the first day.

The Seattle Museum put on an exhibition of the Pre-Raphaelite painters. The Faigins asked me to give a slide lecture. Victorian art had long been one of my obsessions. I had a shelf of books to reread and make slides from.

When we arrived at the Seattle Museum, I saw a poster announcing my talk, admission fee twelve dollars. Even at that, there was

a large crowd in the auditorium. My lecture, a labor of love, went well. Gary and I topped it with a talking tour of the exhibition.

In Santa Fe I gave the same talk for free at the Museum of Fine Arts. There weren't a dozen people in the auditorium.

In the 1990s, an Oklahoma art dealer came by my studio with a painting of a nude. It was signed "Eli Levin." For a few seconds I was confused, thinking that I'd done it. Then I realized that the painting had actually been done by Gary when we were painting side by side.

From Student to Teacher

After failing in my attempt to return to Wisconsin University, I applied to the M.F.A. programs at New York University, Columbia College, and, finally, New Mexico University. Despite my four-point average, they all said no. Was this because my paintings were too Realistic? So much for going back to the safe world of academia.

A friend from Taos, Deanne Romero (formerly Conner and subsequently Matney), asked if I wanted to take over an art class that she was teaching in Española. Her students were having a show in the Española bank. I went with Deanne to their opening, wearing my ubiquitous Brooks Brothers suit. Her students had clumsily copied photographs: sunsets from *Arizona Highways* magazine, snaps of pet dogs, etc. There was quite a gulf between their work and the Modernism of the draft-dodging Wisconsin students. What a difference between bad highbrow and bad lowbrow taste. But where does one find good taste?

Our class met in the living room of Rosina Espinoza, a grade-school teacher who lived with her mother. Rosina was a classic Spanish beauty; the dark skin around her eyes gave her a sad, patient expression.

One student owned Becker's Western Wear, another was the proprietor of Saints and Sinners bar, and a third had a welding shop on the highway. Others were housewives.

I set up some still lifes, but these did not inspire. As I went around, one student after the other would ask, "How do you paint

glass?" So I brought in reproductions of popular Impressionist and post-Impressionist paintings, thinking they might like to copy them. More resistance. They went back to copying from calendars, magazines, and snapshots.

I tried to explain some color theory, complementary colors and the concept of warm and cool. They countered with the advice that Deanne had given them: "Mix a bit of yellow ochre with all your colors to achieve harmony."

At the time, I privately had nothing but contempt for this yellow ochre business. Now I wonder. In my search for harmony, I often let one color dominate.

At the end of our last class, my students brought cookies to Rosina's dining room table and served coffee and even wine. I was touched. As we were all sitting around the table, several of them spoke up. They did not think I was a good teacher.

Looking back, I have come to the same conclusion. My various students don't become inspired by the things I care about, such as good draftsmanship, anatomy, and perspective. They just want to express themselves. Of all the people I've showed how to use egg tempera, no one has ever stuck with it.

More Attempts at Teaching

As time went by, I taught various art classes in my studio. Then, in the 1980s, I was invited to teach painting at the Santa Fe Prep School. I would be paid twenty-five dollars an hour, the highest salary I'd ever received. The classes were two afternoons a week.

I was determined that there would be no artsy-craftsy projects or unbridled self-expression. I would imbue the students with basic technique. They would paint still lifes in oil on canvas.

About a third of the students could follow my program. Another third were irresistibly drawn to graffiti and tattoo imagery. The remainder of the students were distracted, uninspired, or seriously inhibited.

A foxy nymphet tried to talk me into marking her present while she skipped the classes altogether. She batted her eyes while mentioning her mother's high connections in the art community.

I tried to instill good work habits, but these were seriously spoiled kids. Art was the last class of the day, so there was a general distraction and exhaustion. After class, I put in a lot of time getting everything back in order.

However, paintings did get painted, and many were quite strong. We hung them in the school lobby for Open School Day. As I looked around, I was impressed and pleased.

I wasn't hired back. Instead, they got a teacher who treated them like kids, introducing a smorgasbord of art materials and techniques.

Teaching Again

I had some students who spent time in my studio: three middle-aged women and a teenage boy. They came erratically, paying five dollars an hour. Thinking that they might paint more, I reduced the fee to five dollars a day. We set up still lifes and I showed them how to use egg tempera. The young man, Trevor, soon insisted on using oil paint.

The women eventually faltered, but Trevor, very wound up, came every day. (However, he didn't pay.) As the months passed, his paintings just got better and better. Each new still life vibrated with more intensity; some passages were stronger than anything I could do. This went on for about a year. Some years later, Trevor told me that he had been stoned the whole time.

My mentoring came to an abrupt end with a conflict between Trevor and Charlotte, the only other student who still showed up occasionally. She had a tablecloth of red and white squares that she planned to use in her next setup. When Charlotte wasn't there, Trevor appropriated it, incorporated it into his new still life, and started painting. The next day, Charlotte came in. Generously, she offered to tear the tablecloth in half so that they could both use it, but Trevor was

uncompromising. He became obstinate, muttered, stuttered, and finally stormed out. He never painted in my studio again.

Trevor continued working in his basement apartment, but his art became less focused. After some months, he became an Abstract artist, and from there he went on to paint monochromes, basically blank canvasses.

In recent years, Trevor has been going to the University of New Mexico, both as an undergraduate and graduate. A pet of the art department, his art has become a crazy amalgamation of numerous styles.

After Trevor became a university art student, he told me that nobody paints Realist still lifes except old ladies in the extension classes.

Last Attempt to Teach Drawing

Most of those who signed up for my ultimate drawing class had been doing art for some time. Several were in my regular drawing and etching groups. I found that the better they drew, the harder it was to amend their shortcomings. I lectured on the common drawing mistakes and then went around correcting each drawing, emphasizing the same points. The students would glare at me. "I see it that way," or "I like it like this." They would continue to make the same mistakes.

In my student days I, too, was totally resistant to my teachers. With Soyer I inwardly scoffed at painterly facture and continued to pursue a dogged literalness. At the Boston Museum School I loathed their worship of Matisse and emulated the early Renaissance artists. At the Art Students League, with Hale, I was blind to academic precepts and clung to the particular and the idiosyncratic.

When I taught, I seemed to exacerbate my students' resistance. An alternative approach would have been to adapt to the students' preferences and help realize them. But do students have an intelligent sense of direction? Even if they do, why should I help them to develop the kinds of art that I don't like?

Students are oblivious to the art that excited me when I was studying: Heinrich Kley, Goya, Otto Dix, Dürer, Bosch, Grünewald,

Botticelli. Ah, if only students ever wanted to discuss any of these artists. And it's even less likely that they would share any of my current enthusiasms: Mannerism, Victorian art, the Russian Itinerants, the German New Objectivity movement, or WPA art.

Drawing

I've hosted a weekly sketch group in my studio since 1969.

On occasion I would set aside a second evening, hire another model, and teach drawing. I noticed that students almost always make the same mistakes, so I gave it some thought and came up with a list of 44 rules of drawing. For example: Heads too big for the bodies, features too big for the head, eyes too high on the face. I distributed the lists, and every week I would reiterate one rule or another as I corrected their drawings. Nevertheless, the students hardly improved. Why is this?

In the nineteenth century, art students studied drawing every day for five to eight years. Often this was before even picking up a paintbrush. They worked first from engraved reproductions and then from plaster casts for years before trying to draw a live model. For us, confronted with a nude model once or twice a week, most of the 44 rules go flying out of our heads. These rules are just a bare beginning; there are many more factors to doing a good drawing.

Here is the list I handed out, 44 precepts that would hopefully alleviate the most common drawing mistakes:

Some Rules of Drawing

> GENERAL
>> Drawing is the probity of art. (Ingres)
>> Draw lines over conceived form.
>> Think of ribbons, belts, bracelets: interior contours.
>> Check proportions with negative spaces.
>> Check proportions using horizontal and vertical
>>> guidelines.

Squint for large forms.
Consider placement on page.
Stay twice as far from the model as the model's height.
Erase a lot.
Copy Old Masters.

VOLUME

Whole before parts.
Reduce all shapes to cylinders and boxes.
Find patterns of simple geometric shapes.
Reduce hands to mittens, feet to socks, head to egg.
Change in plane: change in value.
Body is made up of convexes.
Indicate floor, props.

LINE

There are no lines in nature.
Line symbolizes edges of planes.
Lines darker in dips.
Crosshatch following interior contours.
Place yourself so there's 2/3 light on the model.
Group shadows, lights.
Eliminate confusing cast shadows.
Conscious use of reflected light.
Include shadows on floor, props.

ANATOMY

Don't make head too big: 7-1/2.
More hair, less face.
Watch head-to-shoulder position.
Remember forward thrust of neck.
Pubis bone ½ way up body, eyes ½ way up head.
Relation of bone masses, pelvis, rib cage, head.
Twist of backbone.

Twist of body; feet to shoulders.

Contraposto: supporting weight, raised side of pelvis, foot under chin, tight and loose side of body.

After bone masses, basic muscle groups.

Draw from origin to insertion.

Copy anatomy.

FORESHORTENING

Find body's direction in space, relative to horizontal.

Foreshorten more drastically than you are naturally prone to.

Reduce length, never thickness.

Emphasize overlaps.

Draw closest elements first.

Heavy use of checkpoints.

Book Learning

When I was a teenager, my attempts at a bohemian lifestyle were influenced by the books I read. I discovered Henry Miller's *Air-Conditioned Nightmare*, followed by *Nights of Love and Laughter, Nexus, Plexus,* and *Sexus*. The last three were on my father's bookshelf. I read Ginsberg's *Howl* and Kerouac's *On the Road* hot off the press. In my search for states of angst and negativity, I read Voltaire, Sade, Huysmans, Dostoyevsky, Sartre, Genet, and Celine.

I've always loved art books, even preferring them in some ways to museums. I like the privacy of studying pictures in an art book and the concentration of related images. Museums try to be encyclopedic, which has a mind-boggling leveling effect.

As a kid, instead of going straight home from junior high school, I would take the cross-town bus east to the 96th Street library. I sat on the floor where the low bookcases held the oversize art books, leafing through one after another. While I was looking for nudes, I found other images that I also liked. The reproductions were mostly black and white in those days. Even so, every picture was rubber-stamped with the name of the library, right on the image.

Nowadays I'm addicted to ordering art books from the endless publisher and remainder catalogs that clog up my mailbox. My purchases are almost always under twenty dollars, but some years when I do my taxes I find that I've spent over two thousand dollars on art books. I favor books that research obscure or unpopular art, such as Victorian art, Russian Realism, and Depression-era artists. I feel sympathy for these books and the paintings in them, so few people will ever care about them.

I've probably learned more from art books than from art teachers. For instance, when I was studying with Raphael Soyer, whom I liked a lot

even though he didn't teach me much, I went to a great deal of trouble to find a copy of Da Vinci's out of print *Treatise on Art*. It had been compiled in the eighteenth century by members of the French Academy and supposedly illustrated by Poussin. I studied it assiduously.

Raphael Soyer himself published several books, which I read as they came out, one even called *Self Revealment*. (I don't find the term "revealment" in the dictionary.) While his books have a certain unassuming sincerity, they are as uninformative as he was.

Robert Beverly Hale also published some books that elucidate his teachings, the best being *Drawing Lessons from the Masters*.

Thomas Hart Benton wrote a powerful autobiography, *An Artist in America*, which I've read twice.

Other twice-read favorites include Diego Rivera's autobiography, Pissarro's letters, Van Gogh's letters, Gauguin's *Intimate Journals*, Delacroix's journals, Paula Mohderson-Becker's letters, Maria Baskietchev's journal, and George Grosz' *A Little Yes and a Big No*.

Some more obscure artists' autobiographies and journals that I liked are those of Nina Hamnett, Maurice Sterne, Harry Wickey, Boudin, and Fromentin.

How To

Among the multitudes, there are a few exceptional how-to art books. There is a little known treatise by Maurice Grosser, a very honest approach to Realist painting. Grosser seems to be only known today because of a poster of Georgia O'Keeffe riding tandem on a motorcycle that he is driving.

Many endearing how-to books do, however, contain information that I consider misleading. For example, Carlson wrote a wonderful treatise on landscape painting, but he insisted repeatedly that the sky must be the lightest element in any landscape, as it is the light source. This is a poetic idea, but I have seen his concept disproved by tin roofs, white walls, and even reflections in water.

Carlson's dictum brings to mind Gary Faigin's teaching of landscape painting in New Mexico. Gary insisted that his students paint the sky a third of the way down the value scale. This made the blue unnaturally dark, but very intense, as the New Mexico skies are.

Robert Henri's *Art Spirit* was the art bible when I was a student, but aside from his infectious enthusiasm, it is a grab bag of bromides and dubious prescriptions. He insisted that the whites of the eyes should be painted the same color as the flesh and that one should never depict eyelashes or fingernails.

John Sloan's book *The Gist of Art* is much quirkier. He advocates reverse perspective and in general has an anti-Naturalistic attitude that goes against his own best paintings and reflects the Modernistic influence of the 1913 Armory Show.

Art was a very romantic calling in the 1950s, when as students we read Henri and Sloan. Charles Hawthorne excited us with his perfectly matching little patches of color, and Bridgeman awed us with his anatomy book *The Human Machine*. Unfortunately, clever concepts and techniques go just so far.

The most important how-to book for me has been Cennini's treatise on egg tempera, circa 1400, and the updated variation by Thompson. Like Da Vinci's treatise, both were out of print and very hard to come by when I found them. Now all three books can be purchased from Dover Publications for a few dollars. Yet I wonder how many art students read them.

It occurs to me that someone should compile a core curriculum of great art books.

Aesthetic Brainwashing and Censorship by Omission

Art history as published has many hidden agendas. A good example is the dearth of books on twentieth-century Realism. It was only about ten years ago that the first book in English came out on the German New Objectivity movement. What a revelation to discover that

there were so many good Realist artists between the world wars, right in the middle of the so-called Modernist period. Even the New Objectivity book was poorly researched and soon out of print. And just try to find a book of paintings done during the Nazi period.

Art books on Russian Realists are equally rare. Just a few years ago the first book in English came out on Socialist Realism, the major art movement in Russia for 50 years.

By chance I picked up a book with the unlikely title *Art Deco Painting*, by Lucie-Smith. It turned out to be thick with reproductions of forgotten paintings by obscure European Realists of the 1920s. To this day there hasn't been a comprehensive study of twentieth-century Realism.

Even nineteenth-century European Realism has been neglected and distorted by art historians. For instance, socially conscious artists of the late nineteenth century have never been the subject of a comprehensive study. There were many fine painters, the precursors of Social and Socialist Realism. Several of these artists, such as Raphaeli, showed in the eight exhibitions of the independents between 1872 and 1884, the very exhibits that made the Impressionists famous. Hundreds of art books dwell on the five or six Impressionists that were in these large group shows, but none has ever discussed the other participating artists. Ironically, Degas was closer to the socially conscious Realist camp than the Impressionists that he is always grouped with.

Here is another example of censorship by omission: there are innumerable books about Alfred Stieglitz's group of artists, the first American Moderns, but there has never been a single book about the John Reed Club's artists who exhibited during the same period. Many important painters had their first exhibits at the John Reed Club, including Thomas Hart Benton and Raphael Soyer. Artists of the political left are written out of history.

Not all art history lacunae are so obviously political. For years I have searched for books about the Mannerists, an art movement that lasted one hundred years between 1500 and 1600 and spread throughout Europe. In art history surveys the Mannerists are either

skipped or denigrated. Famous artists who did Mannerist works, such as Michelangelo, Breughel, and El Greco, are rescued from the movement as if they had nothing to do with it. Other Mannerists are only mentioned as oddities or for cautionary reasons. The Italian Mannerists are seen as a letdown from the high Renaissance while the Netherlandish Mannerists are passed over as obscure forerunners of the golden age of Dutch and Flemish painting.

My guess is that the art world, which takes such an elevating stance, wants to avoid the cynicism and even anarchy of Mannerist art. Despite general condemnation, Mannerist art has influenced many artists, including the Romantics, the Symbolists, and the Surrealists.

To this day I've only found two well-illustrated books about the Mannerists. One, in French, was an overpriced coffee-table book about the Italians. The other, in Japanese, was a small two-volume set on both the Italians and the Netherlands, designed in a garish, neo-gothic format.

Most art books are crammed with clichés and platitudes. One of the first books I read was the bestseller *Lust for Life*. The author, Irving Stone, did not hesitate to invent a love life for Van Gogh. Later, in *The Agony and the Ecstasy*, Stone invented a female love interest for Michelangelo, who was a homosexual.

In John Rewald's groundbreaking and well-researched *Impressionism* and later his *Post-Impressionism*, the author presented all these artists as geniuses. Books on these artists inevitably suffer from unqualified hero worship. These same books denigrate the other artists of the period.

Mean Artists and Nice Artists

One of the most disturbing aspects of reading biographies of artists is finding out how self-serving and mean-spirited they so often were. In this, Picasso is the undisputed master. Reading the litany of artists' overbearing egos makes it hard to enjoy their work. Some of the

worst are Michelangelo, Caravaggio, Courbet, Manet, Gauguin, O'Keeffe, Benton, Hopper, and Pollock.

At the other extreme, there were unassertive and unfulfilled artists such as one finds in the heartbreaking journals of Maria Baskietchev and letters of Paula Modersohn-Becker, both of whom died before they were thirty. They were martyred to male egos: Maria to her teacher Bastien-Lepage and Paula to her artist husband, Otto Modersohn.

Books about Aesthetics

A wide range of art theories impressed me as a student: Tolstoy's *What Is Art?*, Wölfflin's binary *Classical Versus Baroque*, Berenson's *Tactile Values*, Kandinsky's *The Spiritual in Art*, Marinetti's *The Futurist Manifesto*, Fry's and Bell's *Significant Form*, Rodman's *Form Versus Content*, Rosenberg's *Action Painting*, and Greenberg's *Formalist Reductio ad Absurdum*.

These all caught my imagination when I read them. Each made a strong argument that helped me understand art. I wouldn't give credence to any of them now.

Going back to earlier writings about art, I was particularly impressed by Cennini, who I have mentioned, Vasari's *Lives of the Artists*, Cellini's autobiography, Goncourt's writings on the Rococo period, Fromentin's *Dutch Masters*, Diderot's *Salons*, Baudelaire's extolling of Delacroix at the expense of Ingres, Delacroix's own interminable worrying over Expressiveness, and Whistler's *Ten O'clock Lecture* and *Gentle Art of Making Enemies*.

Baudelaire described Ingres' art as "The complete expression of an incomplete temperament." Despite the brilliance of Baudelaire's essay, I consider Ingres to be much the better artist.

The Secret Of Art

What have I learned from my pursuit of the extensive literature about art? Perhaps only how to act like an artist. I've picked up such a lot of judgments, values, systems, hierarchies, all the exclusivities that artists imagine separate us from the philistines, not to mention from each other. Art snobbery pours forth in an unending stream in literature and, most particularly, in art magazines. Do all these niceties of judgment mean anything at all? Art, like God, is a subject about which a spectacular amount of pure speculation has been written. Well, spiritual devotees go on questing and praying, and I go on painting. Sorry, no secret of art here.

Art for the People

From the time I was a student until well into my middle age, I had strong beliefs. I thought of myself as a Realist, more particularly as a Social Realist. I kept the faith with what I imagined was a close-knit group who disdained Modern Art. We were painting for the people, who were honest souls who would instinctively understand our vision. If only given a fair chance, the public would be in sympathy with our populist humanistic ideas. They would reject the esoteric elitism of Modern Art. We preferred traditional Western art, WPA art, and Mexican murals. We were sure that any sensible person who hadn't been indoctrinated by the contemporary art world would agree with us.

So where are these ordinary people? They're at home watching television. If they ever come in contact with art, they have terrible taste.

Now that the years have flown by, I have to admit that, despite

the isms endlessly permuting, there is only one game: the contemporary art world. My lovingly preserved out-of-print books, announcements, catalogs, and clipped articles, all that evidence of twentieth-century Realism, are doing nothing but sitting on the shelves gathering dust. To use a phrase from my high school social science teacher, Social Realist painters are "tassels on the lunatic fringe."

Furthermore, I have been taking contrary positions for so long that I have become possessed by the very spirit of contrariness. I like the contention better than the cause. If Realism came into fashion, I would probably be against it.

Realist artists who were once cult figures, such as Hopper, Balthus, and Freud, have become superstars. Co-opted by the art establishment, the contrary edginess to their works seems to have evaporated. They have become the quaint exceptions that prove the rule of Modern Art.

Jealousy and Art

Jealousy and envy are ugly emotions. I do my best to repress them, but I'm very prone to artistic envy. I am uncomfortable in the presence of successful painters and other art-world personages. I complain about being excluded from the inner circles of the art world, but on those rare occasions when I find myself in the company of art personages, I freeze up, feeling like a spy or a saboteur.

My high school sweetheart in New York was Mimi Gross, the daughter of the sculptor, Chaim Gross. When I went away to college, she fell in with a group of artists a few years older then me. First there was Jay Milder, a handsome fellow who painted in a dark Romantically Expressionist style. After Jay, Mimi hooked up with Red Grooms, an even more charismatic painter from the same circle, whom she married.

Running away from the tensions of the art world, I moved to New Mexico, as I have said. A year later, in 1965, I tried to move back to New York. Mimi graciously attempted to introduce me into her circle of friends, some of whom I'd known before. I found that I couldn't bring myself to accept her invitations.

In the 1960s, Realism was dead in the water. I harbored the bohemian mindset that artists were outsiders. If they were finding acceptance, they were selling out.

In the 1970s, a Realist movement developed in New York. I kept in touch, visiting every year, making the rounds of the half-dozen Realist galleries.

In the 1980s, the New York Realists made a concerted effort to insert themselves in the art scene. Between teachers and students, there were five hundred of them who showed simultaneously all over New York. I came to New York and ran around to all the little galleries and alternative spaces that featured this miraculous upsurge. I thought there were a lot of good paintings, and I certainly wished that my work had been among them.

This putsch came to nothing, and Realism sank back into relative obscurity.

In the 1990s, the Academy of Realist Art began coming to Santa Fe during the summer art seasons. Most of the visiting painters who taught workshops were from New York. It was ironic that I hadn't been able to show with the Realists in New York, and now they were coming to my home territory, outmaneuvering me. I was envious of my friend Gary Faigin, now head of the Academy, the virtuoso teachers that he hired, and even some of the more gifted students.

Envy often turns my judgment from positive to negative discernment. When I flip through *Art News* and *Art in America* every month, I hate almost every image that I see. Wouldn't it be nice if I could like more contemporary art, as so many people seem to do? Is there any validity to the discriminations I make about art, or am I just a fool?

A Technical Digression

I had struggled with underpainting techniques throughout my career, often in ways similar to Earlbacher's, which resulted in very dark oil paintings. Because of my love of egg tempera, I've come to use a

lighter, looser *terre verte* underpainting traditional to the medium.

My paintings are not technically exceptional; they have no virtuoso or obsessive application. Still, I like conscientious workmanship. Occasionally I look things up in Mayer's and Doerner's books on technique.

I first saw a teacher demonstrate the egg medium in 1961 at the Boston Museum School. Over the years, my method evolved away from compulsive hatching with a tiny brush, the method used by traditional egg tempera artists. I work more loosely and change colors and shapes as I develop the image.

Many artists, dealers, critics, and patrons can't distinguish an egg tempera from an oil. It doesn't help that art books don't talk about techniques.

There is a book about Thomas Hart Benton's students, amusingly titled *Under the Influence*. Thirty artists are featured, and the text is rich in anecdotes, biographical information, photos, and reproductions. Most of the paintings are listed as egg temperas, but there is no other mention of this technique in the book. This was a serious oversight, because Benton used an unusual technique called egg-oil emulsion, a viscous fast-drying mixture that he then glazed over with thin oil paint. Benton's followers, using a variety of egg tempera techniques, were a major factor in the revival of techniques that had been almost totally neglected for five hundred years.

Egg tempera was replaced by oil painting between 1400 and 1500. Botticelli shifted from the one to the other in the late 1400s. Books on Botticelli don't discuss this important transition in any detail, despite its being one of the paradigm shifts in art history.

I prefer the Middle Renaissance to the High Renaissance. The egg tempera artists were individualistic, inquisitive craftsmen who painted colorful original panels. The oil painters were officious courtiers. Their paintings were grandiose and generalized, the colors muddy.

In my studio the battle between egg and oil continues. The bad shelf: Crumpled oil tubes clogged up around the caps, clumsy stiff bristle brushes, a dark palette crusted with dry paint, toxic mediums, and

solvents in their sticky containers. The good shelf: Little bottles of pure, luminous powdered pigment, perfect Kolinsky sable brushes, porcelain palettes and dishes, mortar and pestle, eggs, and the mixture of yolk and water in a little pharmacy bottle.

Art Peeves

Here I move on from my personal learning experiences to venture my own contrarian thoughts on art.

Lies About Art

ARTISTS

Giotto was more important than Duccio.
Delacroix was more creative than Ingres.
Degas was an Impressionist.
Picasso's *Les Demoiselles d'Avignon* is a masterpiece.
Picasso's *Guernica* is a political masterpiece.
Matisse was a good draftsman.

ART HISTORY

Greek sculpture was better than Egyptian sculpture.
High Renaissance was superior to middle Renaissance.
Mannerism was a low point between Renaissance and Baroque.
Academic art is bad.
The Impressionists were misunderstood, had no backers, were poor, and could draw.
After the Impressionists there was no good Realistic art.
The Surrealists were antisocial.
Nazi and Stalinist art was all bad.
Abstract artists could draw like Old Masters if they wanted to.
The Stieglitz group were good artists.
Abstract Expressionism was a great art movement.

COMMON MISCONCEPTIONS
> Most artists were misunderstood and poor.
> A few geniuses were superior to other artists.
> Sketchiness is more artistic than high finish.
> Never use black.
> Shadows in landscape are purple.
> Artists paint for themselves.
> It doesn't matter if you paint an apple or a Madonna.
> The two-dimensionality of the surface should be respected.

Thoughts about Academic Art

To call a work of art "academic" is to condemn it. After all, the Impressionists triumphed over the academy. Scholars beyond number have extolled the brave Impressionist outsiders who challenged the entrenched and moribund academic artists. But try to find anything written about those unmentionable academicians.

In recent years, it is true, a few revisionist historians have timidly approached the edges of academic art, not without caveats and traces of lingering disdain. One of the first of these books was titled *Some Call It Kitsch*.

Five hundred years of Western art tradition, from 1400 to 1900, encompassing the studio practices of the Renaissance, Mannerist, Baroque, neo-Classical, Romantic, and Realist movements, has been largely preserved through academic teachings.

In New York in the 1970s, when the new Realist artists tried to develop out of the Modernist canon, their compositions were flat, their surfaces meager, and their drawing faulty.

To best understand the Old Masters, to think as they did, artists should try to learn as students in the European academies were trained.

A traditionally minded artist would do well to resist the mindsets of the Impressionists, post-Impressionists, and Modernists. Without this mindset, one becomes aware that Degas couldn't complete a picture, Renoir couldn't compose, Manet's perspective and proportions were shaky, and so on.

I do like many things about the Impressionists, but they have been touted beyond all reason. I feel that more can be learned from nineteenth-century academic painting: French, Italian, German, Russian, Scandinavian, even the "American Impressionists" (who were basically academic artists).

If one is looking for brilliant color in landscape painting, the Victorian watercolorists painted as brightly as the Impressionists a generation earlier. For a variety of landscape moods, the Scandinavians and Russians have great depth of feeling and are better than the Impressionists at integrating figures into their landscapes.

For subject paintings such as myth, history, and contemporary life, one must look beyond the Impressionists.

Gallery Business

From my high school days until the present, I have been visiting art galleries. I've felt that the galleries are my link to the art world. Yet galleries are private businesses that exist to sell to collectors. Artists should be thankful that galleries let us come through their doors.

The gallery system mediates between the artists and the public. There are many problems in this arrangement.

The gallery manager takes on the role of authority figure to his artists, combining traits of a parent, big brother, boss, drill sergeant, and parole officer.

The exhibiting artist needs a fair amount of his work to be well hung at all times, plus seasonal solo exhibitions, advertising, and networking. Few galleries meet all these criteria. Nevertheless, the gallery takes half of the profit, yet does not pay for framing and often not for publicity.

Galleries are not equally interested in everything that the artist creates. They want a signature style: these sell, those don't. Even within the given style there are restrictions. Paint all the adobes you want, but please, no cars. Paint abstractions, but please use bright cheerful colors.

If the artist and the gallery can negotiate these hurdles, and if they can find a viable market, then there is hope.

Now consider the economics. If our successful artist can paint a picture per week and sell them all for $2,000 each, he or she will gross $52,000 a year. Subtract $5,000 for framing, $2,000 for supplies, $6,000 for studio rent. These are low estimates. Our artist has made $39,000. That's if everything sells. How enthusiastic is a commercial gallery going to be at this financial level? I have been told that galleries need their artists to gross $100,000 a year to run a viable business.

At my best I have taken in $30,000 a year. Not all of it came through my gallery; I had to wheel and deal. More than one gallery didn't take kindly to my business methods, and I was back on the street with another demerit.

Now let's consider issues of quality. In Santa Fe, dealers are surprisingly ignorant of aesthetics and art history. They almost never look in on one another. But they somehow develop an uncanny ability to sense the values of paintings. Their main interests are selling and socializing.

Imagine that our heroic artist has passed all the hurdles I've mentioned. He has painted fifty canvasses that he is proud of, fairly consistent without being unduly repetitious. Despite scant publicity and simple framing, they all sell to an appreciative and expanding public. The prices can be gently raised.

How long will our artist be able to keep this up? Taste changes every few years. Even if the public does remain faithful, can our artist keep his edge after producing two or three hundred variations on a theme? Will the quality of the art increase while our artist's fresh self-expression segues into a virtuoso signature style? It happens all the time. Just ask any successful dealer.

Lives Of The Paintings

I have sold hundreds of paintings, my best among them. When my paintings were sold by galleries, often I was not permitted to know who purchased them. Selling the paintings myself, I met my patrons, which was sometimes just as upsetting.

Those who bought my work were not collectors in any exalted sense of the term. My paintings were not destined for public display, such as, ideally, in museums. It is unlikely that they will ever be seen by anybody in the art world. My life's work has disappeared into private homes in Texas, Chicago, Los Angeles, and other, more obscure, locations. Some are on the walls of living rooms and bedrooms. Most are probably in closets, basements, attics, storage, second-hand stores, or landfills.

Once in a while, someone will try to sell a painting back to me. I'd like to buy them, but I can't afford to. Like most artists other than the big names, my work has no resale value, or as they say in the trade, no secondary market.

As I've mentioned, I painted twenty graveyard scenes in Cummington, thirty cityscapes in Cincinnati, forty still lifes in Wisconsin. Where are all those paintings today?

Ars Longa, Vita Brevis

Do artists make works of art in order to leave a memorial to themselves? I used to think so: a lifetime of effort to leave a grand epitaph. Such is the myth of the misunderstood genius.

The reality is that, after artists die, their art almost always loses esteem and value. There are many reasons for this. First of all, the creator's animating ego is no longer there to draw attention to the art. Once the artist is gone, there is only a small chance that someone will promote his or her art. How likely is it that they will succeed if the artist failed? Furthermore, to make posthumous promotion feasible, there must be a well-stocked estate of artworks available. This is more likely if the art was unsaleable. Even if there are a lot of works of high quality, it is likely that they will seem dated. The art world is prone to denigrating art from the previous generation.

Negativity

My brother tells me, and I agree, that there is a sadness about this document, that most of the incidents end in frustration or failure. I have always had a nihilistic nature, and I suppose that a life in art has aggravated my negativity. Young artists be advised. Now I will conclude the book with some encouraging words.

Inspiration

Because I don't like Modern Art, most people think that I'm narrow-minded. In my defense, let me point out that I do appreciate hundreds of artists and art movements that the vast majority of contemporary artists have never heard of. Does a classical musician have to like contemporary music?

As a teenager sitting on the library floor pawing the art books, I was inspired. Georgione's *Sleeping Venus* was my idea of perfection. There were other beautiful women, nude but also clothed, by Van der Weyden, Fillipo Lippi, Botticelli. I was also fascinated by grotesque depictions of women, such as those by Dürer and Cranach, so full of a disturbing reality. Many artists had personal visions that awed me, such as Bosch, Breughel, Goya, and Rembrandt. These artists opened up the world for me.

I have been engrossed with a vast amount of art, mostly European paintings done between 1350 and 1900. Countless times I've wandered through the halls of the Metropolitan Museum, the National Gallery, and other major museums, gratified by one marvelous passage of painting after another. Though I might have seen the same paintings many times, I could concentrate on different aspects: how light models form, the warm and cool of flesh tones, perspective construction.

Analogous inspiration exists outside of the museums. There is aesthetic pleasure in looking at so many things: a pretty girl, a landscape, even a well-designed household object. This pleasure is intensified for the artist when he draws a model, does a watercolor of nature or paints a kitchen still life.

Light is inspiring. Everything depicted in art is dependent on light. Many works of art are about light. Evening light, autumn light, light coming through a window: these effects are often infused with

heartbreaking beauty. Sunlight playing across a landscape can be so inspiring that I can't help but think that outdoor painters of all people have the greatest chance of coming close to the meaning of life.

There is a comforting beauty in the simplest shapes. I find it inspiring to contemplate an egg or two. Tools are beautiful, too. The world is full of lovely things. It's enough if an artist transcribes a few common objects with feeling. Paintings have innumerable messages and meanings, but many a time I've been stopped in my tracks by the depiction of some simple detail that seems to be perfect in itself.

An artist's inspiration might come to him or her from a dream, a relationship, a book or movie, the ambiance of a place or situation. The artist senses an image forming in his or her mind. Then again, the artist might just conjure up a configuration of forms or colors that express a feeling or some kind of energy. Artists' mental states, too, can materialize into paintings; one feeling might inspire a pastoral, while another will evoke dark congestion.

A very pleasing kind of inspiration can come on as a sudden sense of well-being; preoccupations fall away. Then again, inspiration might be heightened awareness such as one might experience in closely observing nature or watching children at play.

Conversely, inspiration can come during a fever or from pain or anger as a need to release pent-up feelings.

Still another kind of inspiration results from watching a task being performed with expertise. For instance, watching a good carpenter or listening to a well-thought-out disposition.

Finally, there are displays of emotion that trigger inspiration, such as witnessing someone standing up for their beliefs or making a loving gesture.

Surely there are many more kinds of inspiration. But sometimes it is a lack of inspiration that makes me want to run to my easel. For instance, too much talk about sports, dogs, or diseases. Once in my studio, I never wait to be inspired before I paint, as some artists do. For me, the very brushes are inspiring; the first mark that I make on a white rectangle is inspiring; likewise mixing the colors, likewise developing the painting.

Disturbing Art Lessons

I wrote this book in order to bring back memories and to ponder how I became an artist. So many biographies of artists only tell the reader that, as a child, the hero drew all over his schoolbooks and then, as a young man, apprenticed with some pedestrian artist and quickly surpassed him.

In my experience, there were myriad art lessons from the experiential to the didactic, from the sublime to the ridiculous. The significant lessons were those that helped me become an artist. The very best brought shifts in my perception and led to a personal and sustained vision.

I hope that the reader will have discovered, through my examples, how complex and intriguing is the matrix of concepts that can influence a young artist. It has been my goal to supplement the over-simplified romantic notion that artists are inexplicably inspired geniuses. I believe that artists are best understood in the context of their times and places, particularly in relation to the other artists around them.

Acknowledgments

During the fifteen or so years since I started writing this book many people have made suggestions that helped and encouraged me; thank you.

In particular, I'd like to thank novelist Robert Mayer, poet Gabriel Levin, proofreader Janet Bookbinder and artists Sarah Freeman, Abby Mattison and Eric Thomson.

www.ingramcontent.com/pod-product-compliance
Lightning Source LLC
Chambersburg PA
CBHW020919180526
45163CB00007B/2808